PORTRAIT OF THE
YORKSHIRE WOLDS

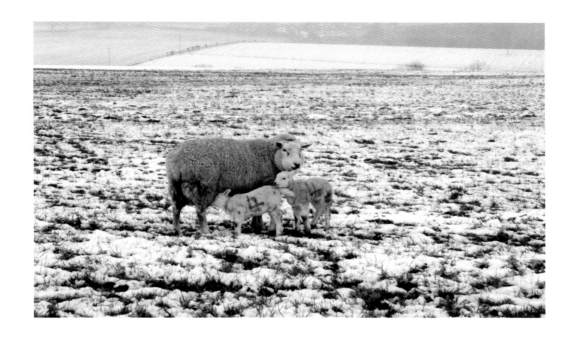

JANET & PETER ROWORTH

HALSGROVE

First published in Great Britain in 2010

British Library Cataloguing-in-Publication Data
A CIP record for this title is available from the British Library

ISBN 978 1 84114 914 1

HALSGROVE
Halsgrove House,
Ryelands Industrial Estate,
Bagley Road, Wellington, Somerset TA21 9PZ
Tel: 01823 653777 Fax: 01823 216796
email: sales@halsgrove.com

Part of the Halsgrove group of companies.
Information on all Halsgrove titles is available at: www.halsgrove.com

Printed and bound in India on behalf of JFDi Print Services Ltd

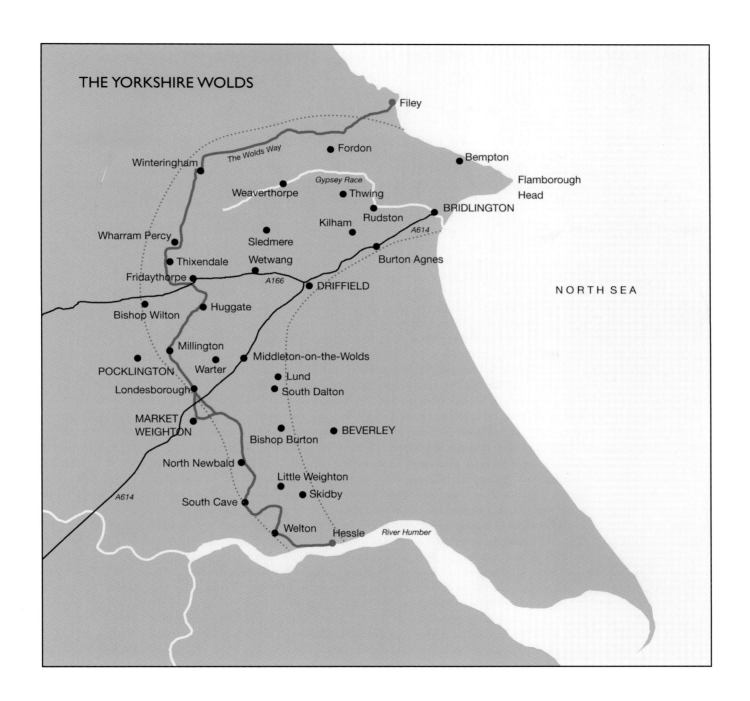

THE YORKSHIRE WOLDS

Filey

Fordon

Winteringham
The Wolds Way

Bempton

Flamborough
Head

Weaverthorpe
Gypsey Race
Thwing

Kilham
Rudston

BRIDLINGTON

Wharram Percy

Sledmere

A614

Thixendale
Wetwang

Burton Agnes

Fridaythorpe
A166
DRIFFIELD

NORTH SEA

Bishop Wilton
Huggate

Millington

POCKLINGTON
Warter
Middleton-on-the-Wolds

Londesborough
Lund
South Dalton

MARKET
WEIGHTON

Bishop Burton
BEVERLEY

North Newbald

Little Weighton

A614
South Cave
Skidby

Welton
Hessle
River Humber

3

Introduction

Many would regard the Yorkshire Wolds as one of Britain's best kept secrets. For a long time the Wolds have been overshadowed by the better known Yorkshire Dales and the North York Moors, which both attract large numbers of tourists with their superb scenery and open spaces. However the gentle rolling landscape of the Yorkshire Wolds has its own unique character. It is formed from a band of chalk which stretches from the north bank of the Humber estuary in a sweeping curve around to the North Sea, ending in the cliffs at Bempton and Flamborough Head. These northern hills are a continuation of the same chalk formation that forms the Wessex Downs and the Lincolnshire Wolds. It is the bright white chalk, which was formed millions of years ago from the skeletal remains and shells of a long lost sea, which gives the area its special quality. The Wolds are incised by a network of steep-sided valleys that were formed by the streams and rivers of a wetter age. Most are now dry and the steep slopes and narrow valley floors are left as pasture for the grazing of cattle and sheep. One exception is the wide Great Wold Valley which carries the stream known as the Gypsey Race, but even this runs dry at certain times of the year. The vast field tops above the valleys are given over to arable farming. During the winter months when the land is being ploughed and cultivated the white chalk content of the soil is clearly visible. At other times there is a patchwork quilt of green, brown and yellow as crops of wheat, barley, oilseed rape, peas and potatoes grow and mature ready for harvesting. Much of the natural woodland that once covered the Wolds has been lost, but plantations and shelter belts have been created to protect many of the farmhouses that were built in the eighteenth and nineteenth centuries when the vast open sheep walks were enclosed.

Where the Wolds reach the sea there are the spectacular cliffs at Bempton. Every possible ledge on the steep chalk face of the cliffs is utilised as a nest site by the thousands of seabirds that return each year to lay their eggs and rear their young. The importance of the site has been recognised by the Royal Society for the Protection of Birds who manage the site by protecting the seabirds and by providing facilities for visiting bird watchers. The headland at Flamborough marks the end of the chalk and it is topped by the lighthouse which sends out its warning beacon of light to passing ships. There are small picturesque coves where the sea laps onto the smooth chalk pebbles and nearby is the seaside resort of Bridlington with its ancient harbour still sheltering fishing and pleasure boats, and its wide sandy beaches and funfair.

The rich heritage of the Wolds includes ancient landmarks like barrows and dykes that show the presence of early man, but the most awesome monument is the 4,000-year-old standing stone in Rudston churchyard. Danish invaders have left their mark in the many strange place names with Wetwang perhaps being the favourite. Some of the early settlements disappeared in the Medieval period and Wharram Percy is the best known and most extensively studied deserted village site in the country. Many of the remaining villages still have their ponds and these now make attractive features. Although it does not make a good building stone, there are a few surviving agricultural buildings and cottages which have been made from the local chalk. There are many fine churches throughout the Wolds, some of ancient origin while others have been built or restored by the Victorians. Splendid houses exist at Sledmere and Burton Agnes, both with beautiful gardens, and there is a working windmill at Skidby.

Driffield regards itself as the Capital of the Wolds although this title was once claimed by the village of Kilham, while Beverley is the county town of the East Riding. Together with Pocklington and Market Weighton they offer weekly markets, a range of shops and a variety of festivals and entertainment. In July Driffield hosts its popular agricultural show which draws in visitors from a wide area. In May Market Weighton celebrates its local hero Giant Bradley, while a horse race, reputed to be the oldest in the country, is run each year on a cross-country course at Kiplingcotes.

Come and explore this forgotten corner of Yorkshire. Drive across the Wolds and it is like being on top of the world, there are big skies, open landscapes, the space is exhilarating and the views are superb. Or walk one of the many footpaths that take you into the deep dry valleys with their wild flowers and butterflies. The Wolds Way is the National Trail that winds its way over 79 miles of peaceful unspoilt countryside from Hessle in the south to Filey in the north. There are cycle routes, bridleways, and some excellent country pubs when you need refreshment. We hope that our photographs have captured the spirit of the Wolds and you will share our enthusiasm for this beautiful example of English countryside.

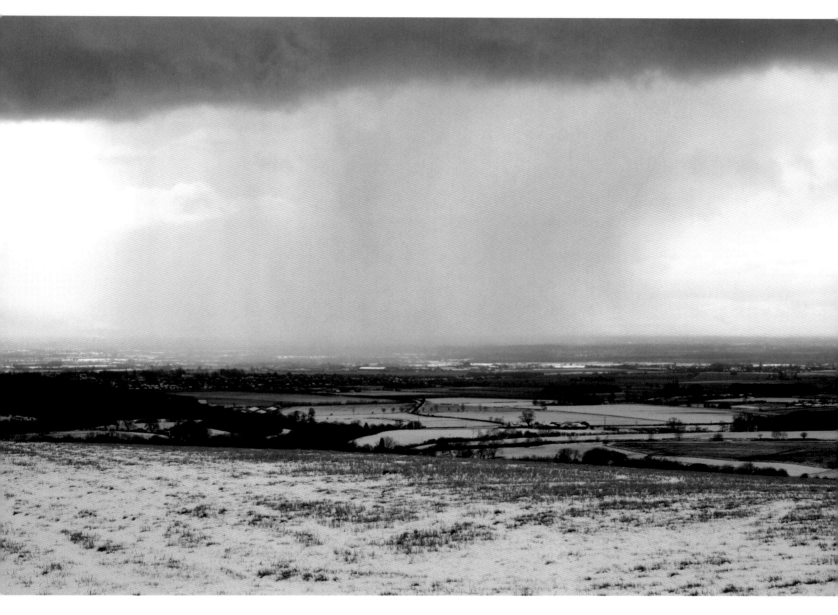

Passing snow shower
A snow shower crosses the Vale of York in this view from Givendale.

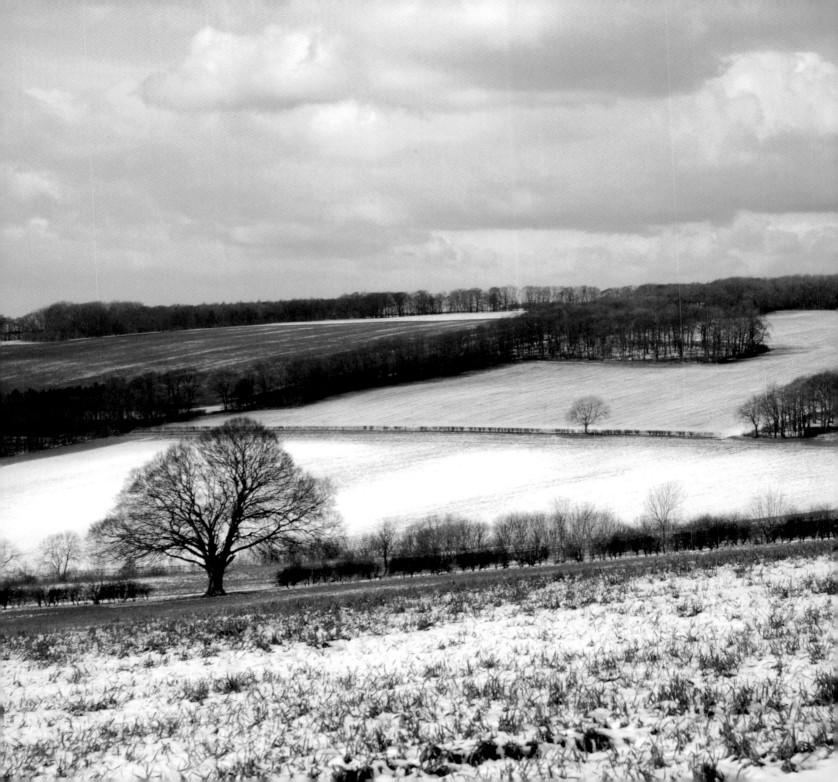

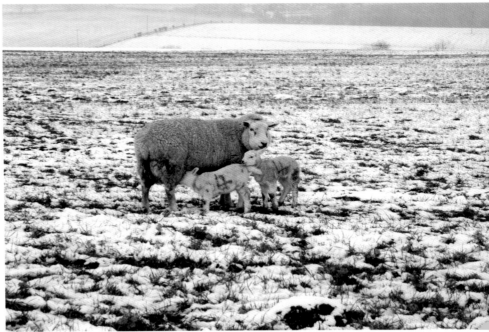

Above:
Spring lambs
A ewe and her two young lambs are
caught out in a spring snowfall.

Left:
Snow scene near Millington
Fields, hedges and shelter belt
woodland with a dusting of snow.

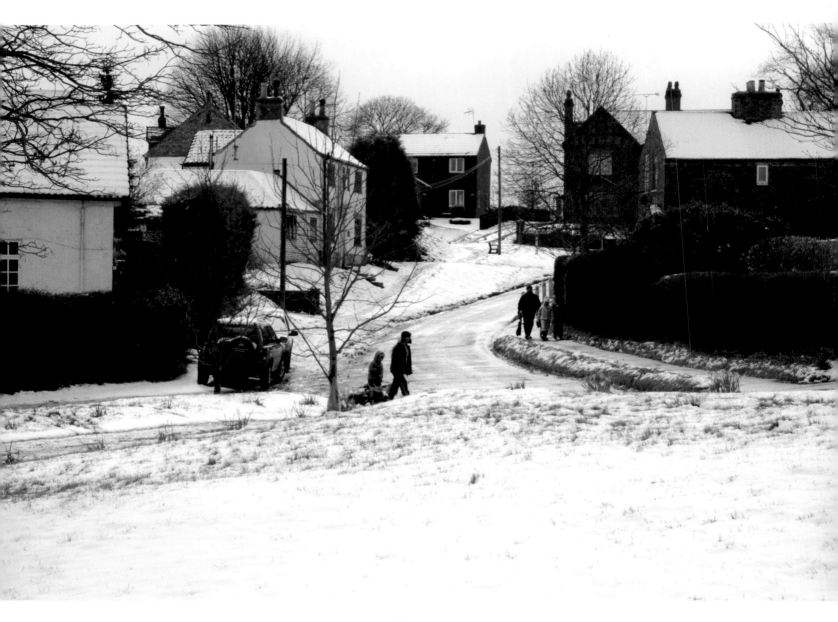

Huggate
Families set out to enjoy the snow while it lasts.

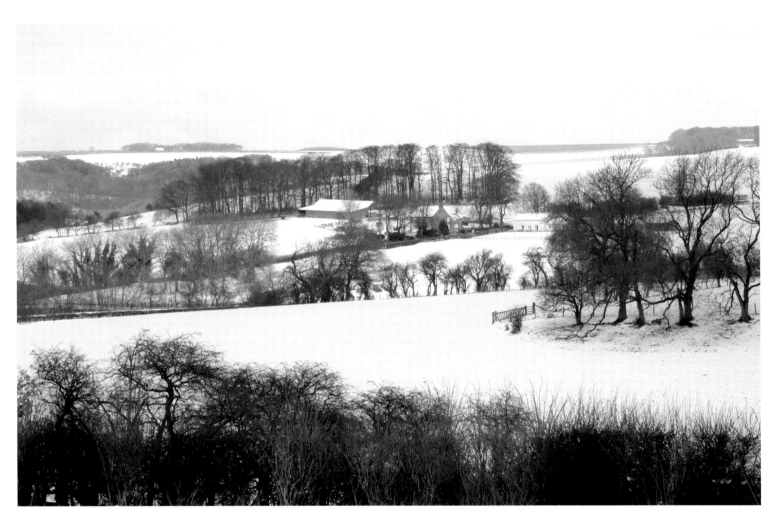

Snow scene near Warter
A red barn and brick farmhouse provide the main colour in this monochrome scene.

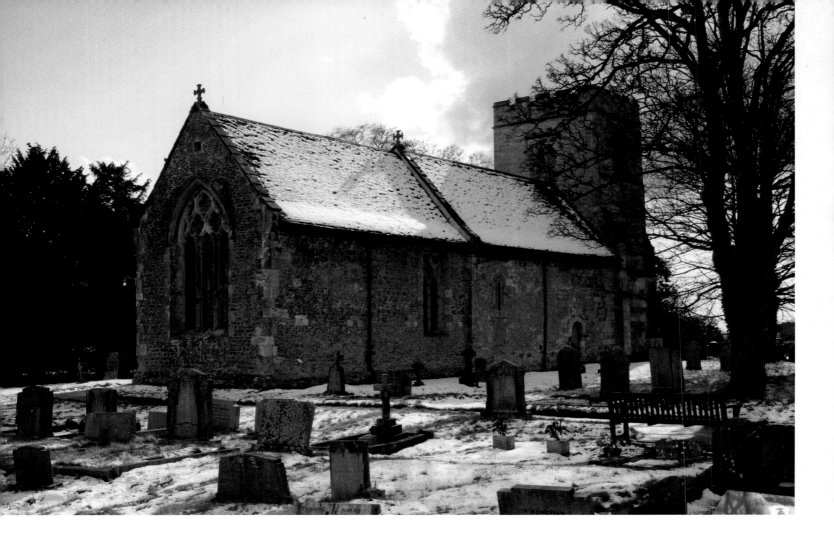

Above:
St James' church, Nunburnholme
During the second half of the nineteenth century the rector of Nunburnholme was the Rev. Francis Orpen Morris.
He studied and wrote about many aspects of natural history but his most celebrated work was his
six-volume history of British birds published by Benjamin Fawcett of Driffield.

Right:
Snow covered branches
The bare branches of a beech tree near Cleaving Coombe are covered with snow –
until the sun comes out and it melts away.

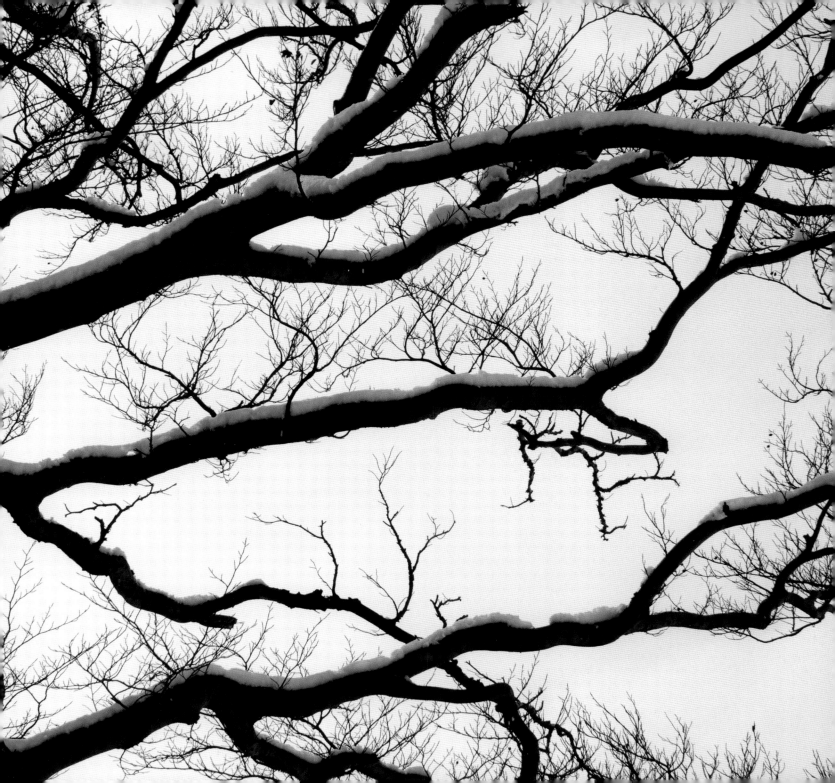

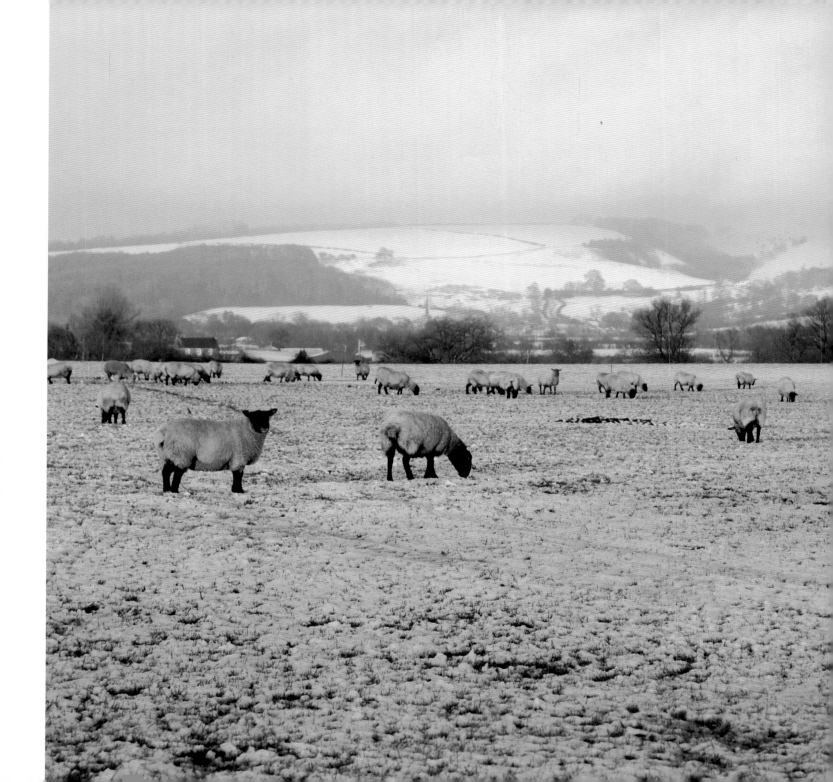

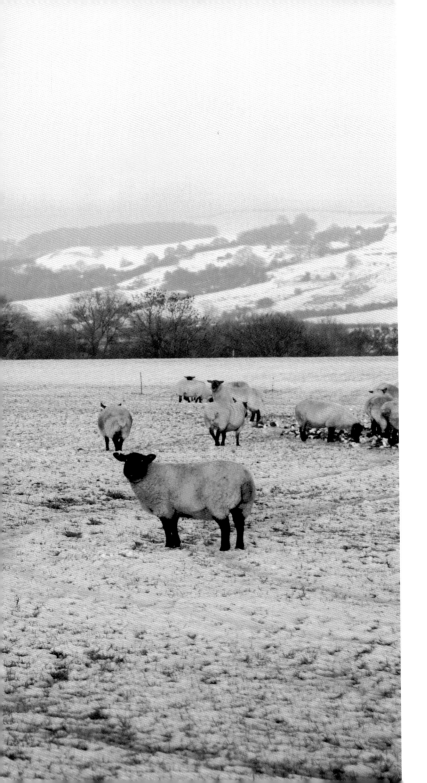

Sheep in the snow at Yapham
Evening light catches a flock of sheep
feeding at the foot of the Wolds.

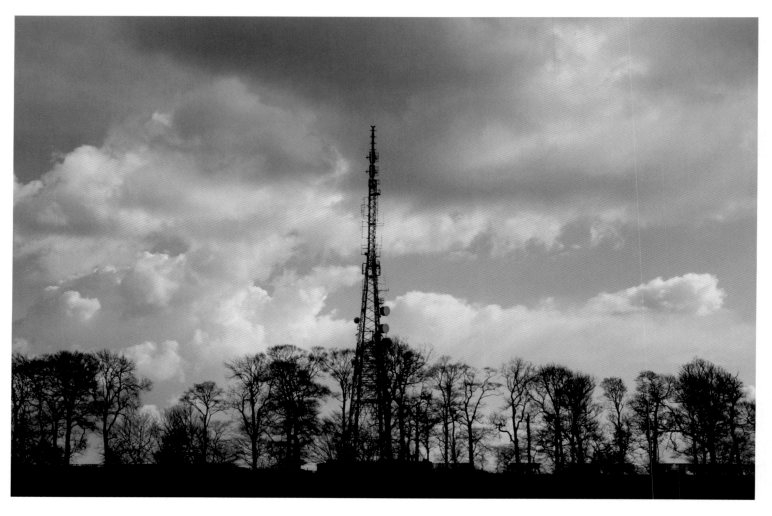

High Hunsley mast
The mast at High Hunsley is sited on one of the highest points on the Wolds at 162 metres (535 ft).

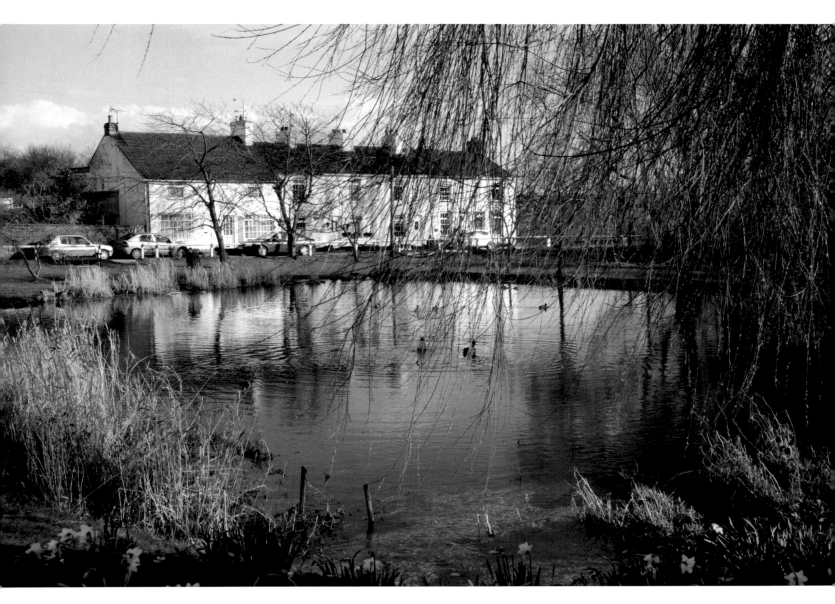

Kilham pond

Although they are no longer used for watering cattle and horses, ponds and their resident ducks are a feature of many villages in the East Riding of Yorkshire.

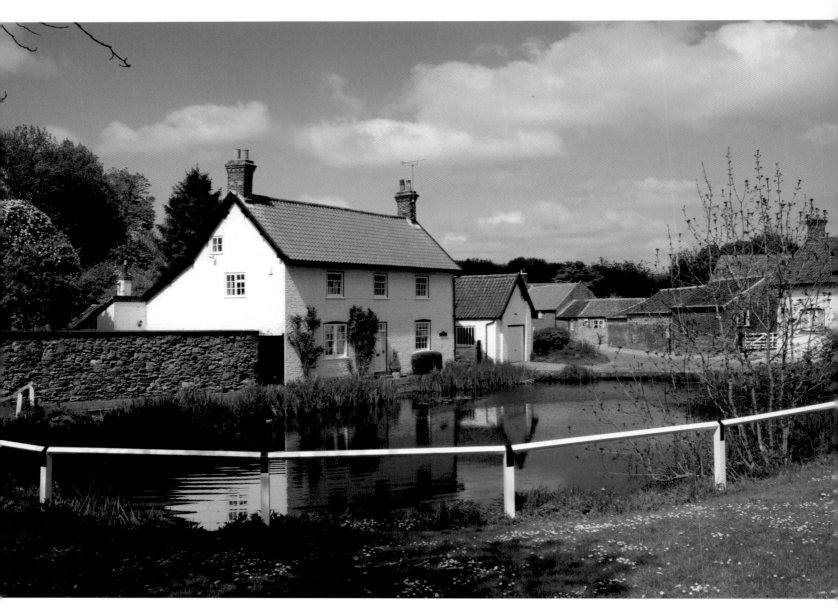

The small pond at Bishop Burton
The whitewashed cottage makes a very picturesque scene at the edge of the village green.

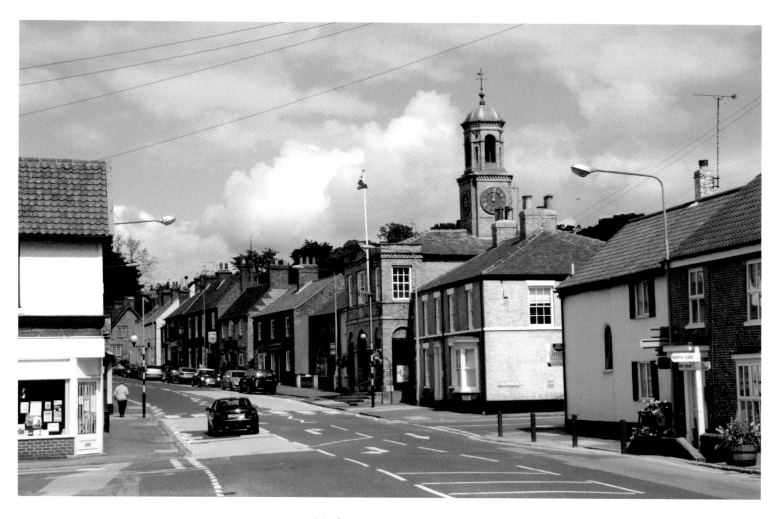

Market Place, South Cave
The Market Hall with its turret, clock and cupola was built in 1796; its presence
shows that there was once a thriving market on the busy main street.

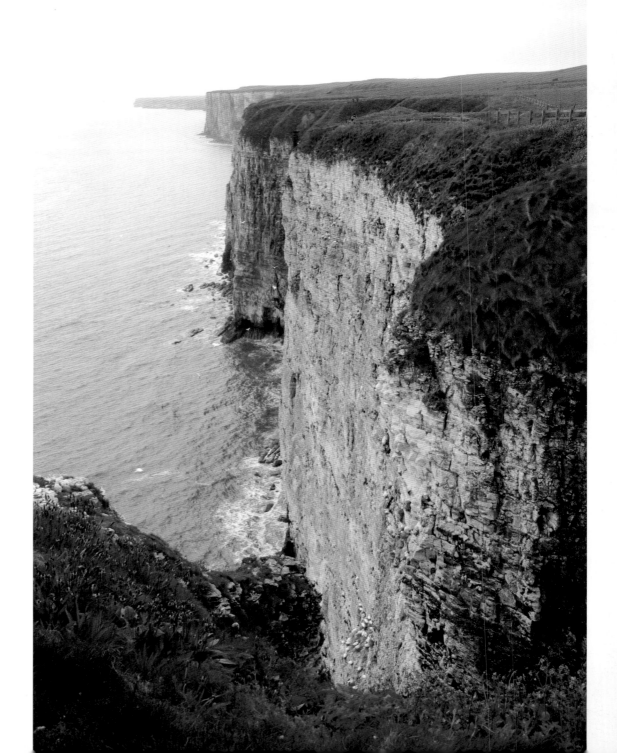

Bempton Cliffs
The chalk Wolds form
spectacular vertical cliffs
where they meet the sea.

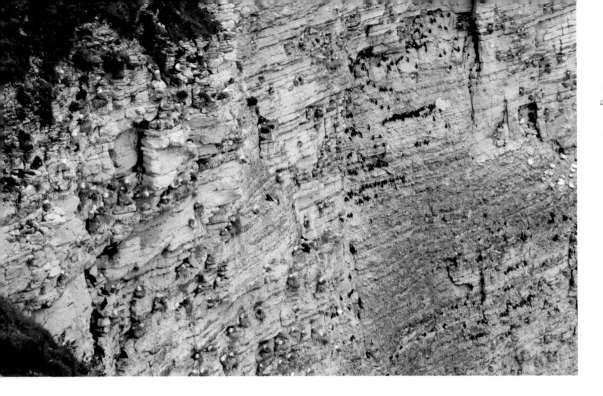

In spring and early summer all available ledges on the cliff face are occupied by nesting seabirds. Here grey and white kittiwakes can be seen together with black guillemots and razorbills.

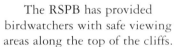

The RSPB has provided birdwatchers with safe viewing areas along the top of the cliffs.

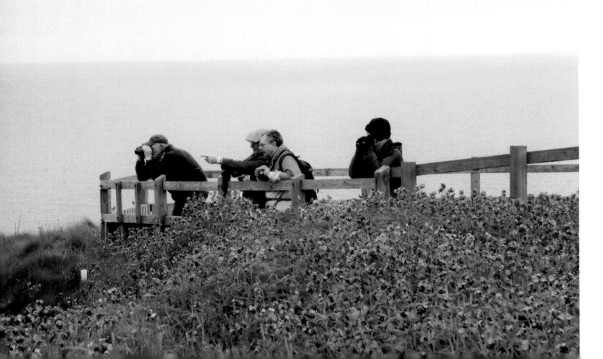

Farm near North Dalton
The chalky soils of the Wolds are clearly
visible in these cultivated fields.

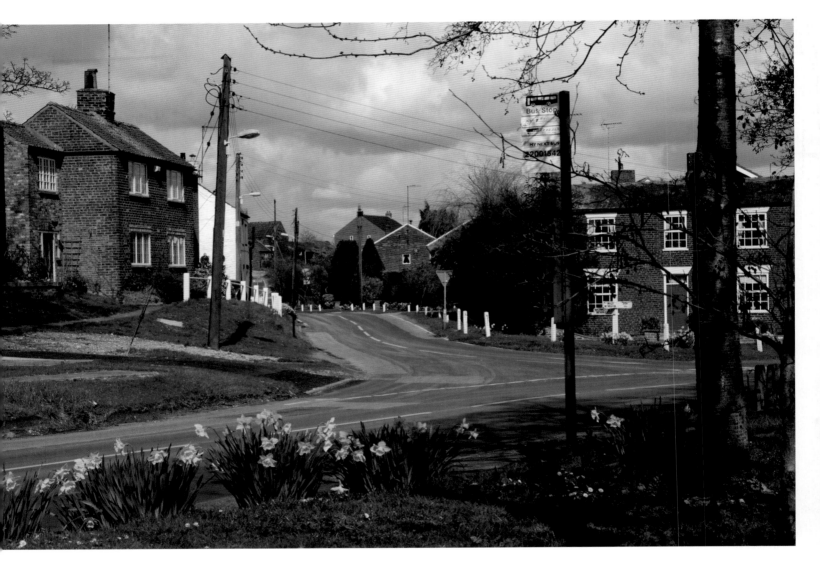

Little Weighton
Yellow daffodils enhance this view of the village.

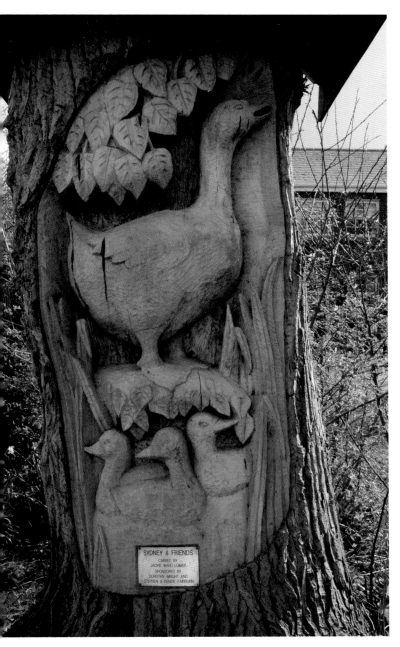

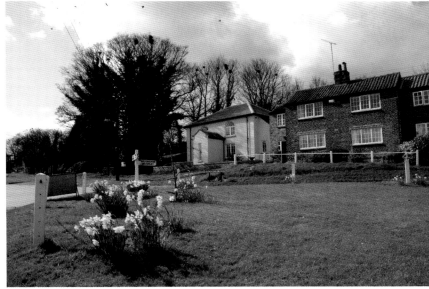

Above:
Little Weighton
The cream-painted former Methodist chapel on the
village green has been converted into a house.

Left:
Sydney and friends
The carved wooden sign depicts the goose known as
'Sydney' and his duck 'friends' who enjoy the village pond.

St Peter's church, Rowley
The church stands next to Rowley Manor which is now a hotel, but there is no sign of a village settlement.

Sancton
Another village with a small pond and attractive red brick buildings, but the
octagonal church tower, just visible in the background, is unique in the county.

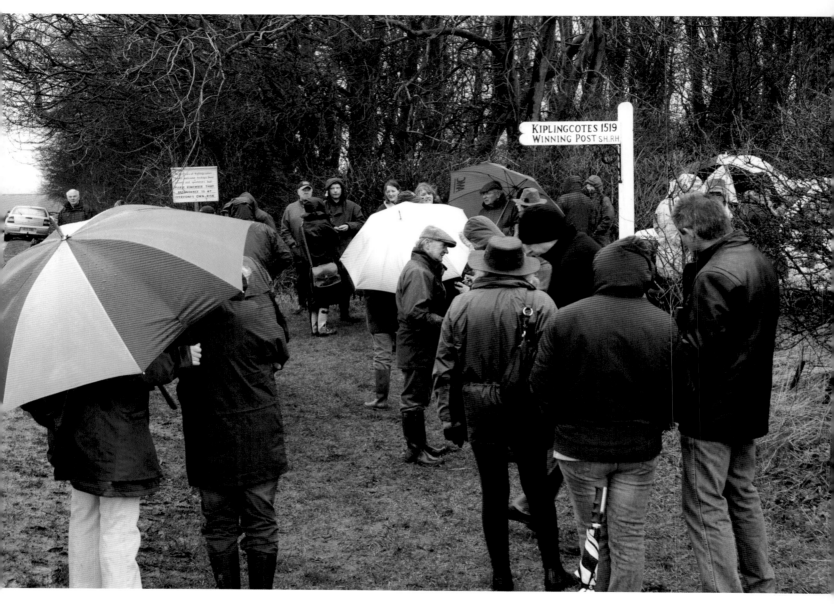

Spectators at the Kiplingcotes Derby

Spectators, huddled together under colourful umbrellas, wait in the rain at the finishing post near to Londesborough Wold Farm.

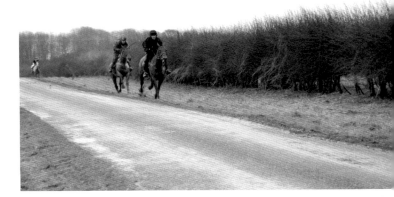

Right:
Kiplingcotes Derby
This is reputedly the oldest flat race in England, dating back to 1519. It is held on the third Thursday in March each year and it is run over a 4 mile course along farm tracks and roadside verges starting in the parish of Etton.

Below left:
The 2008 winner

Below right:
The trophy

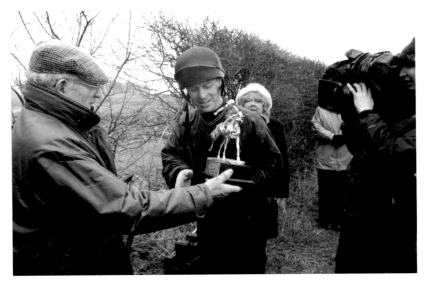

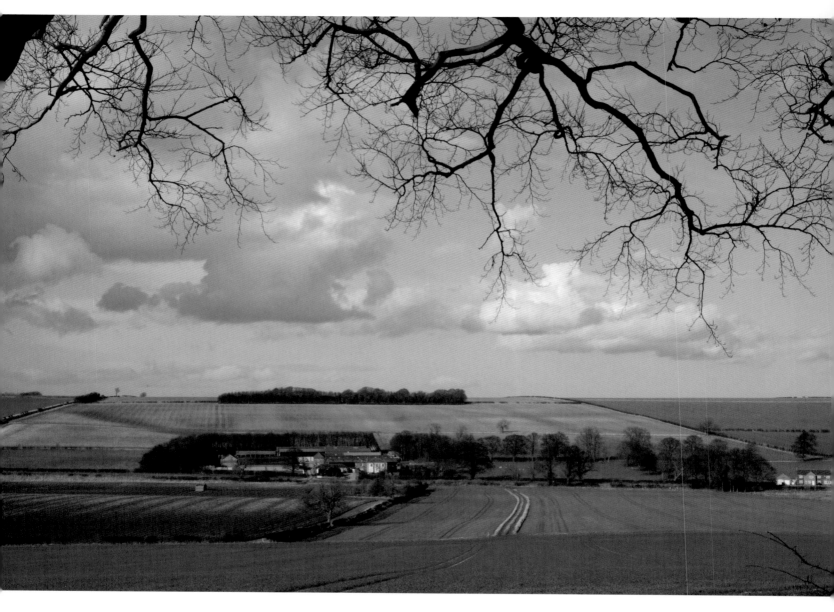

View near Kilham
The trees are still bare but bright spring sunshine lights up this view of Middledale.

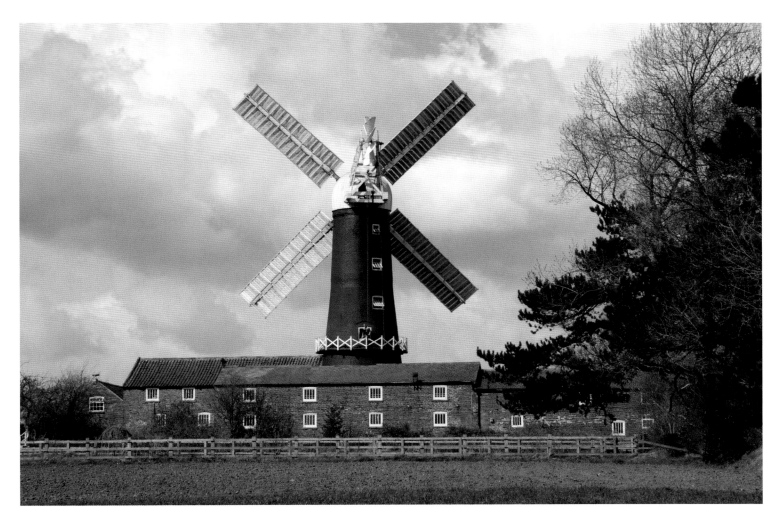

Skidby Windmill
Built in 1821, this is the only windmill in working order in the East Riding. It is now a museum and at weekends, weather permitting, visitors can see wheat being ground into flour in the traditional way.

Field marker
In the 1960s a farmer from Wold House Farm near Huggate placed bell-shaped concrete blocks to mark his field entrances. Many are still in-situ with their strange inscriptions.

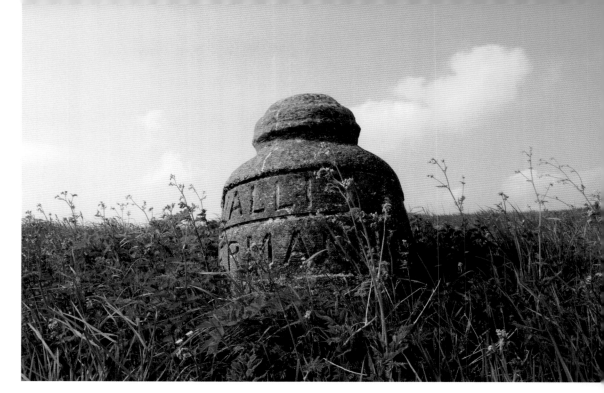

Halifax memorial
A Halifax bomber crashed at this site on 7 February 1944 killing all on board and the driver of a passing milk lorry; this is their memorial on the A166 at Cot Nab.

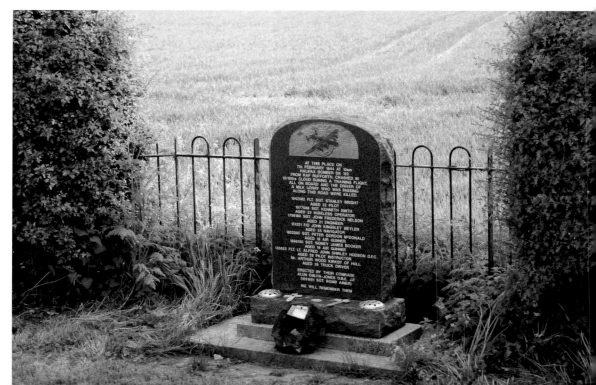

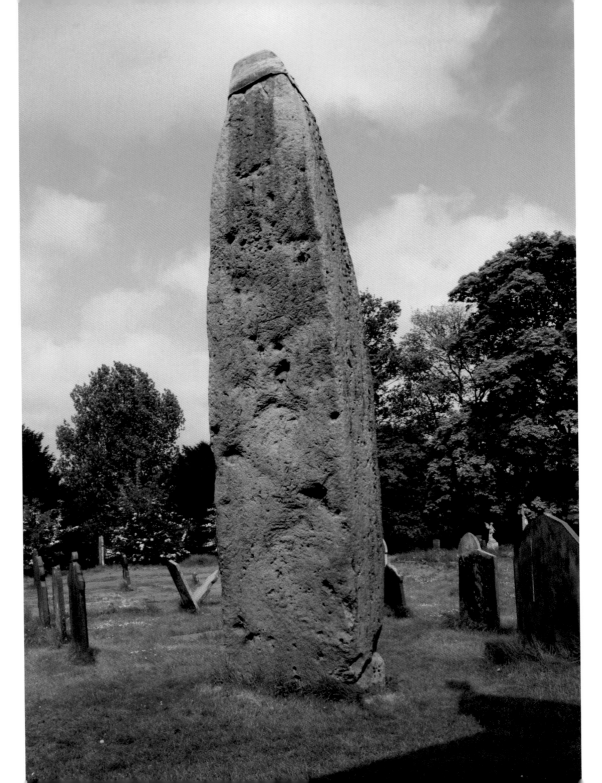

Rudston monolith
This is the largest standing stone in Britain being 7.7 metres or 25 feet high. Legend has it that it was a spear thrown by the devil to destroy the church. More realistically the rock was probably dragged from Cayton Bay or perhaps left as a relic from the ice age.

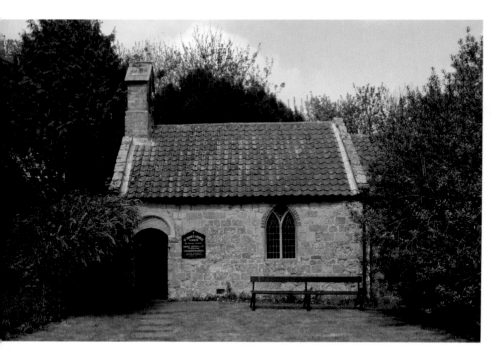

St James' church, Fordon
The tiny church belongs to the small hamlet of Fordon. It has not always been kept in such good condition; at times in the past it was used by outlaws and smugglers and more recently it sheltered sheep and lambs.

Potato planting
Looking like models on a toy farm these six tractors are working the soil and planting potatoes in this field above North Dale at Fordon.

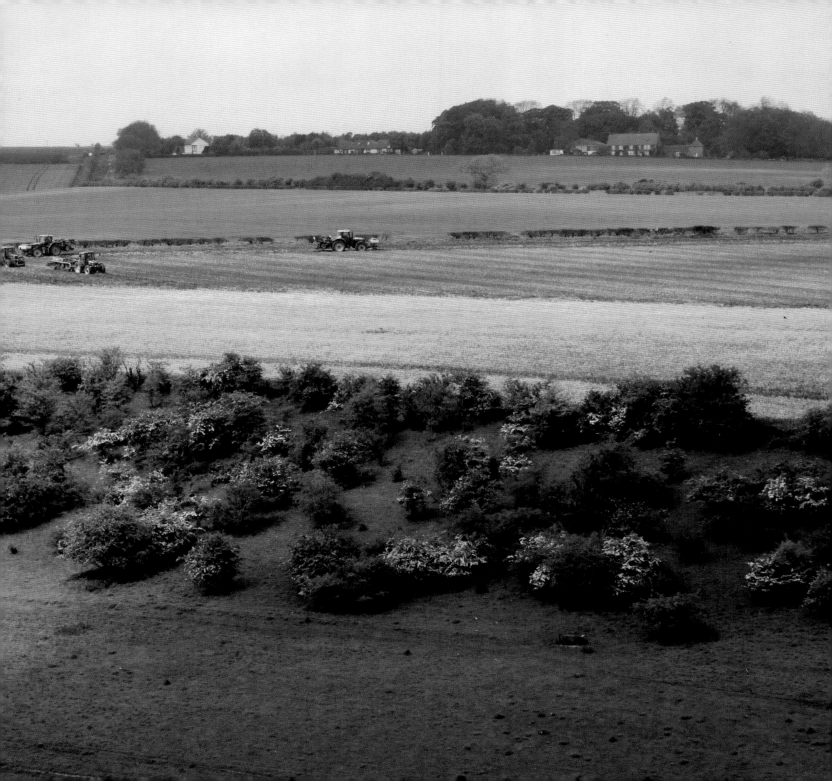

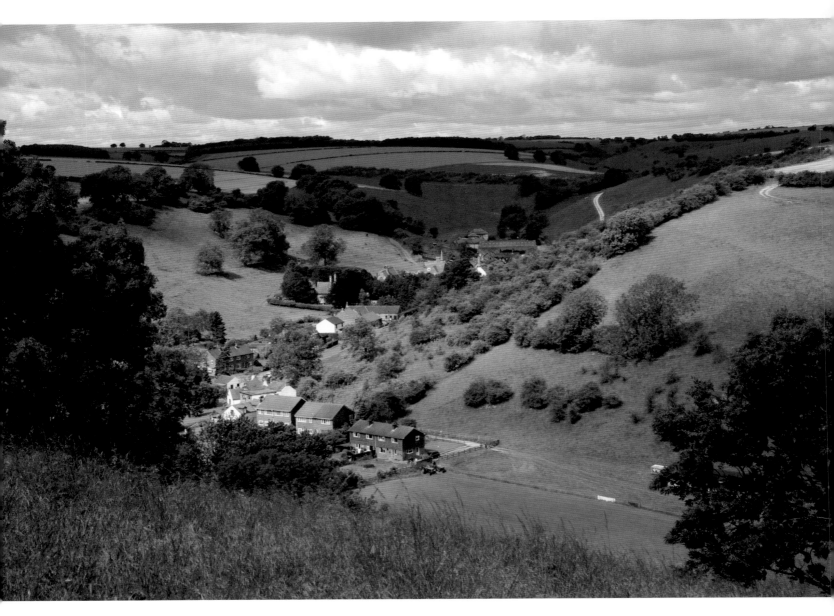

Thixendale
The isolated village lies at the bottom of a steep-sided dry valley.

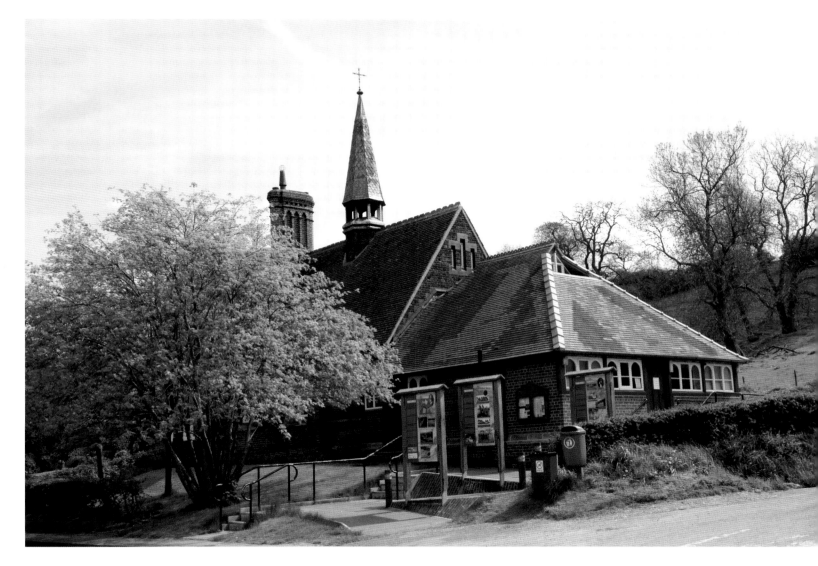

Thixendale village hall
The former school and schoolhouse were used for some years as a Youth Hostel
but they now serve as the village hall, while new display panels explain the village history.

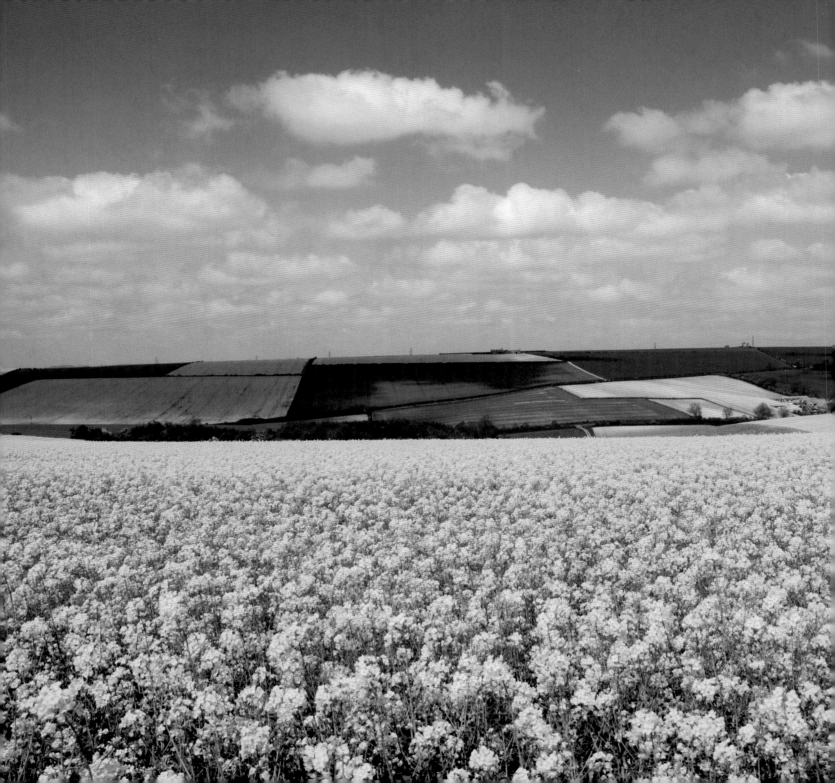

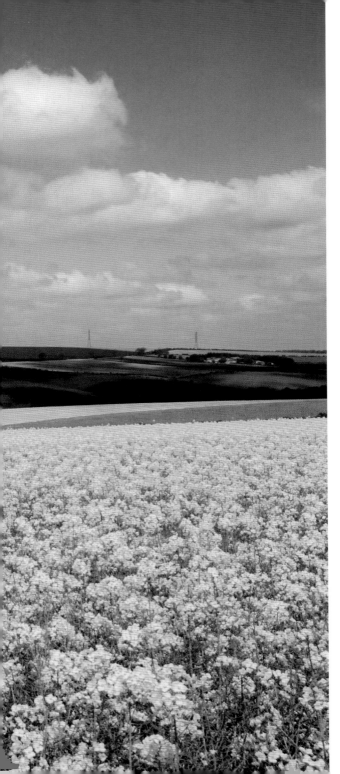

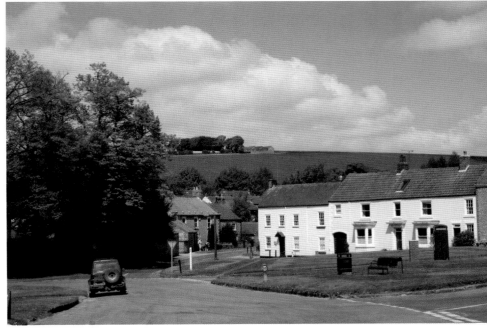

Above:
North Newbald
There is a large green in the centre of the village of
North Newbald which was once the site for a market and fair.

Left:
View over Newbald Wold
In May oilseed rape comes into flower and the Wolds'
landscape is dominated by blocks of bright yellow colour.

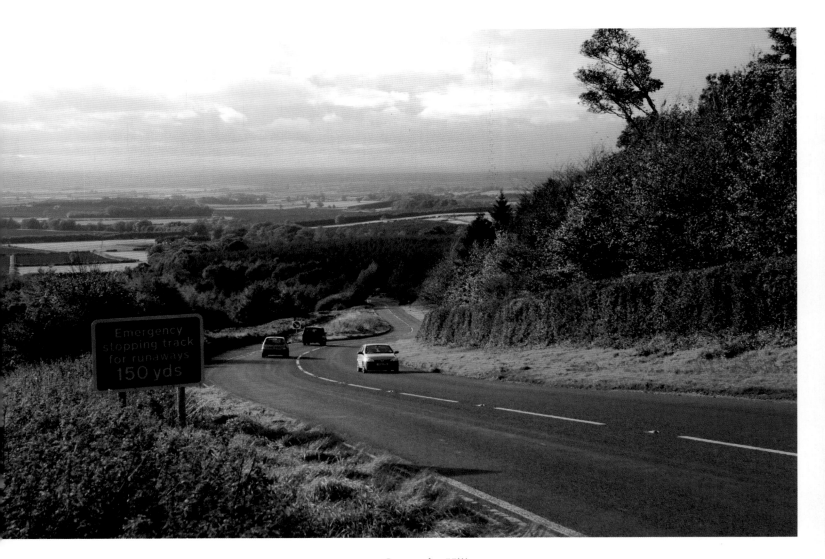

Garrowby Hill
The A166 descends from the Wolds to the flat Vale of York, giving superb views
all year round but causing problems to vehicles in the ice and snow of winter.

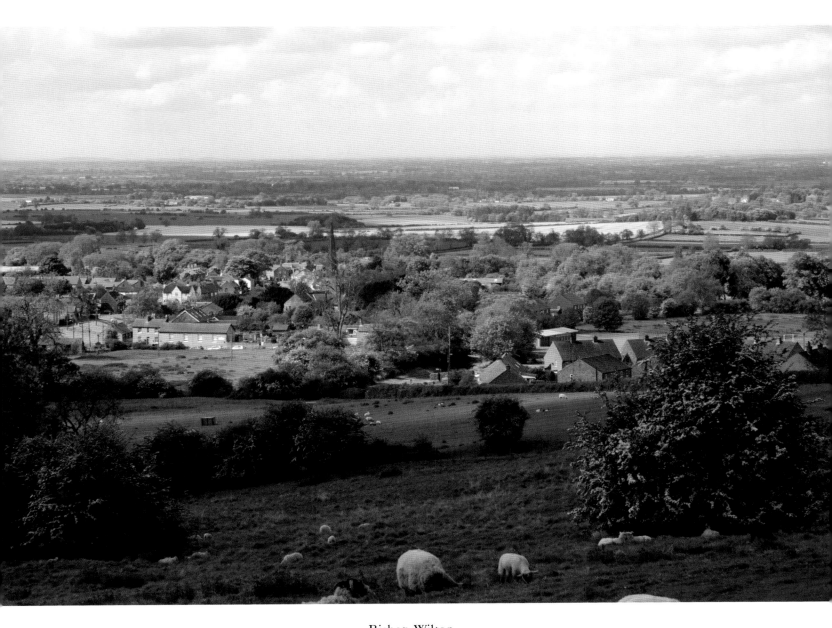

Bishop Wilton
Sunlight catches the church spire and the houses that make up the village of Bishop Wilton, nestling at the foot of the Wolds.

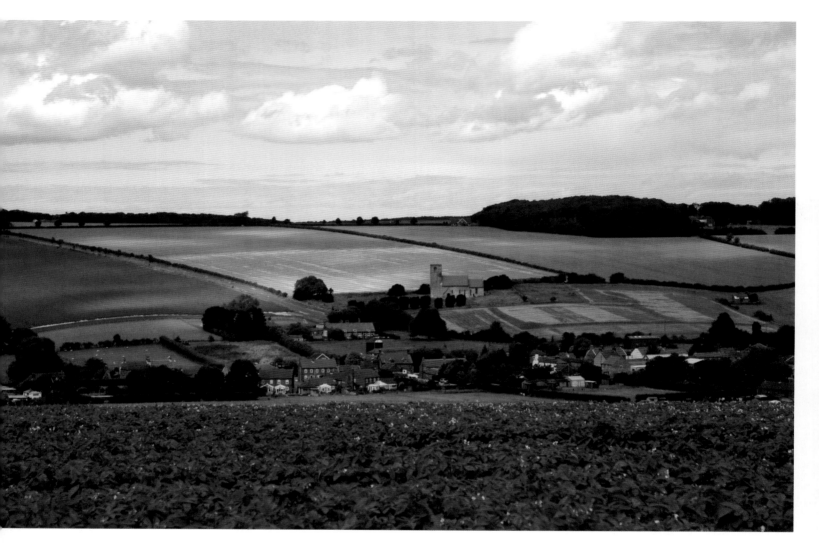

Weaverthorpe
The church stands on the hillside above the village houses which line both
sides of the street and its adjacent stream known as the Gypsey Race.

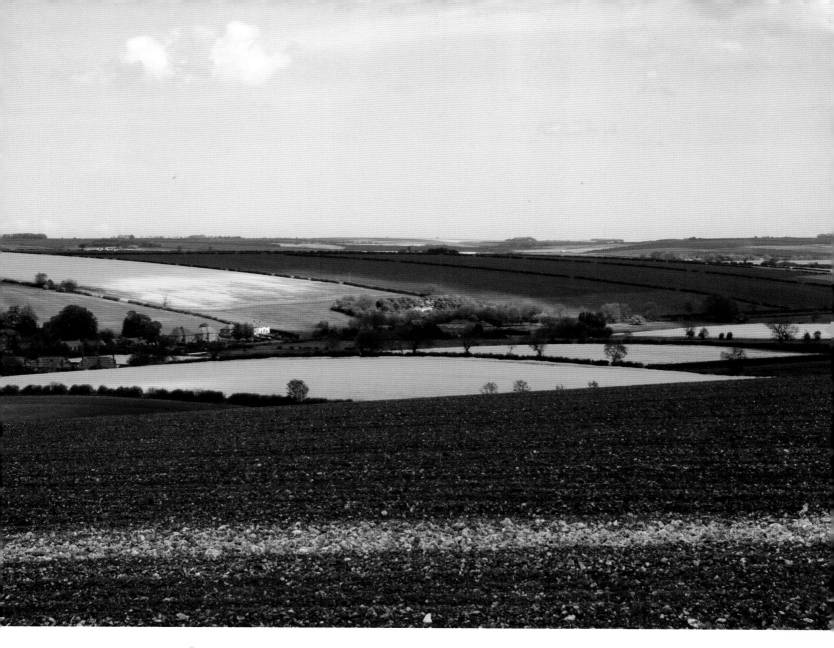

View along the Great Wold Valley
The villages of Weaverthorpe, Helperthorpe and East and West Lutton all lie in the Great Wold Valley,
the largest and broadest valley that crosses the Wolds and carries the Gypsey Race.

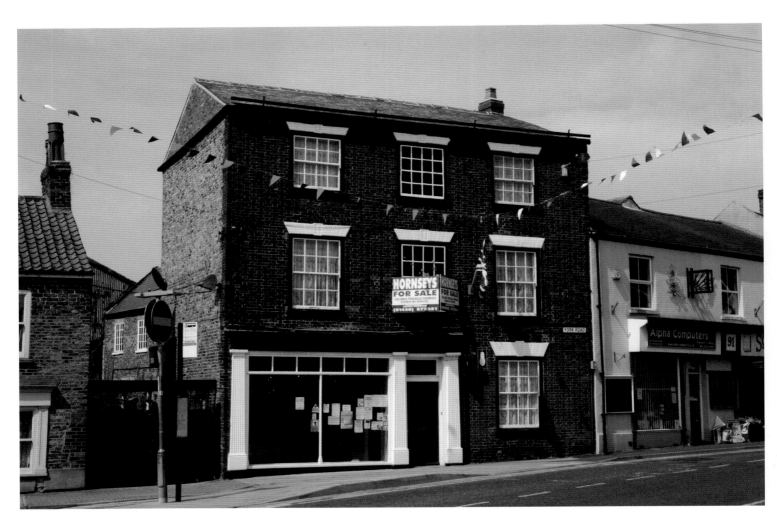

Bradley House, Market Weighton
This house was built with specially heightened ceilings and doors to accommodate
the tallest recorded Englishman known as William Bradley who lived from 1787 until 1820.

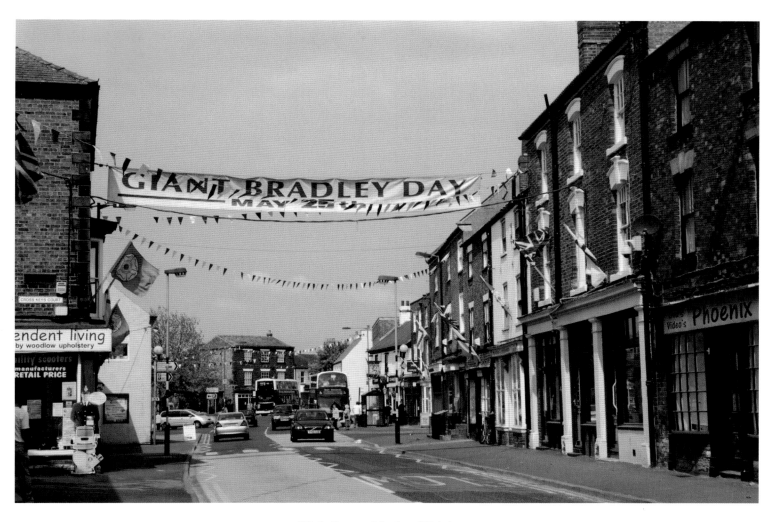

High Street, Market Weighton
The flags are out as the town of Market Weighton celebrates Giant Bradley Day.

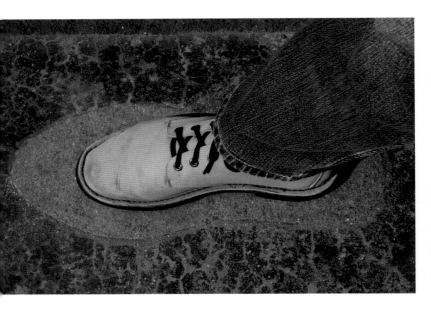

Above:
Giant footprint
Twenty-three granite footprints can be found throughout the
town marking the Giant Bradley Heritage Trail.

Right:
This plaque, which shows an actual footprint of Giant Bradley,
can be found on the wall of Bradley House in Market Weighton.

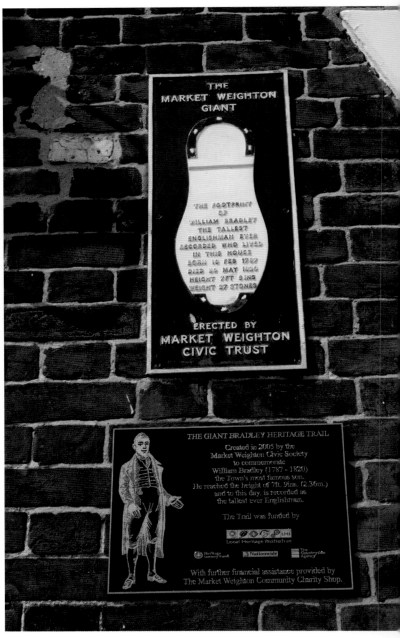

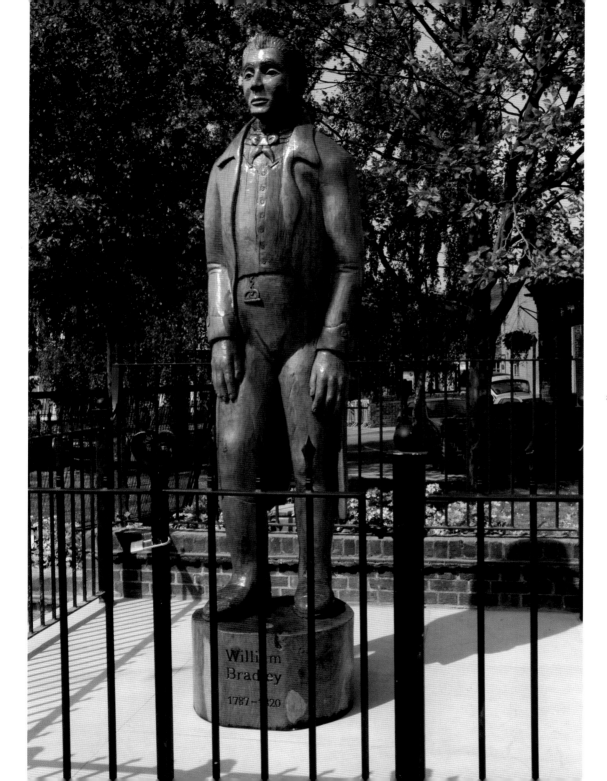

Statue of Giant Bradley

The statue of William Bradley has been carved from an oak log and it stands 2.362 metres or 7 ft 9 inches tall.

William
Bradley
1787 - 1820

Above:
St Mary's church, Fridaythorpe
In many villages the church is the most prominent feature but at Fridaythorpe the historic building is tucked out of view.
It is one of many churches on the Wolds that was restored by a member of the Sykes family from Sledmere.

Right:
Church clock
The unusual and ornate black and white clock on the squat tower dates from the church restoration in 1903.

AÑO DOM̃

XI XII I

X II

IX III

VIII IIII

VII VI V

19 03

Time is short: Eternity
is long

Above:
Green lane
A froth of white cow parsley edges this green lane near Fridaythorpe.

Right:
Oilseed rape
A sea of yellow flowers on Huggate Wold; the crop will eventually
yield oil for the food industry and for processing into biodiesel.

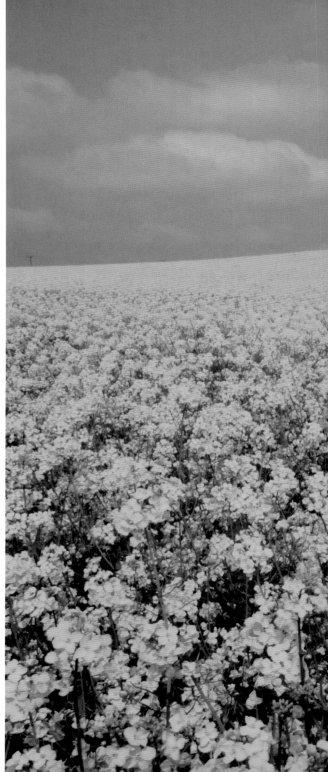

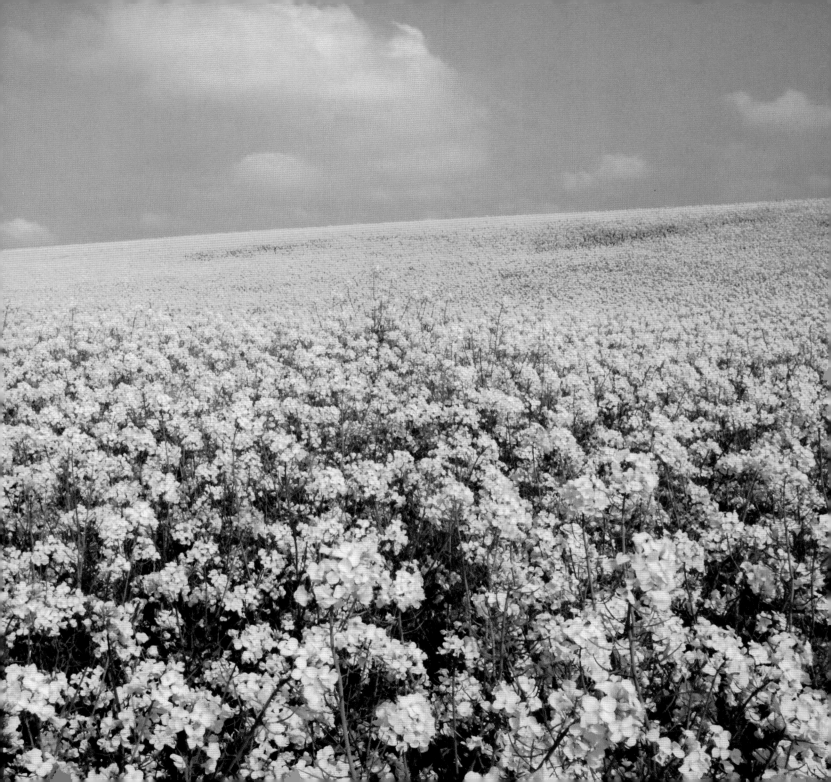

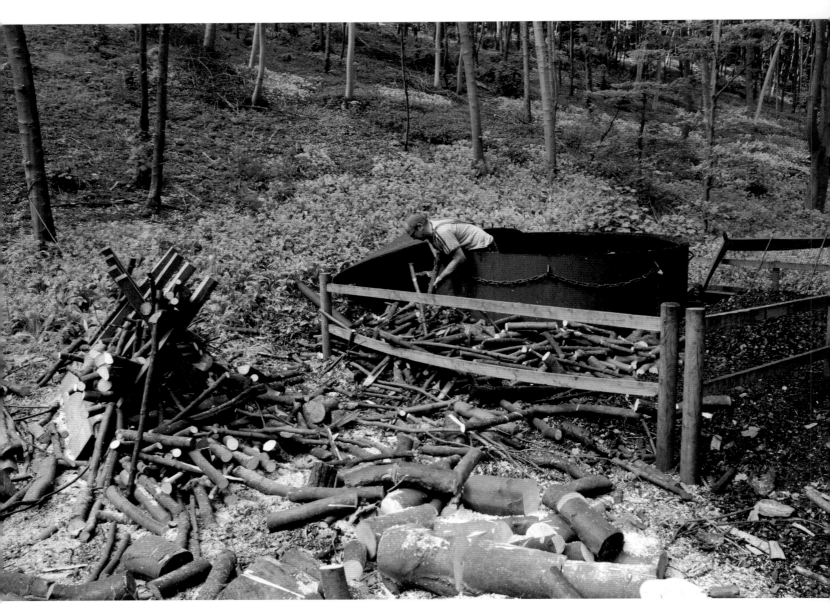

Charcoal burning at Millington Woods
Sawn lengths of timber are stacked inside the large metal ring which will be slowly burnt to form charcoal.

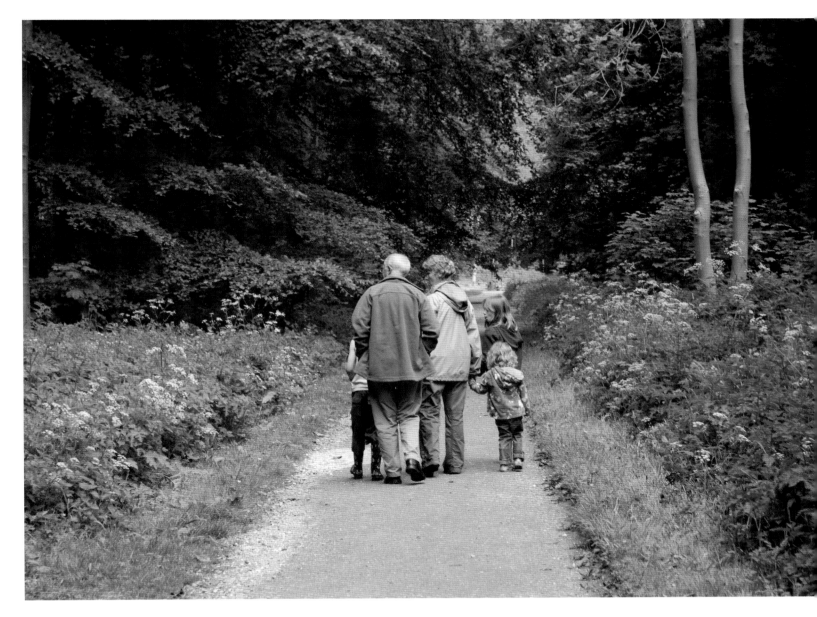

Out for a walk in Millington Woods
A family group enjoys a walk along the footpath in Millington Woods, a Local Nature Reserve.

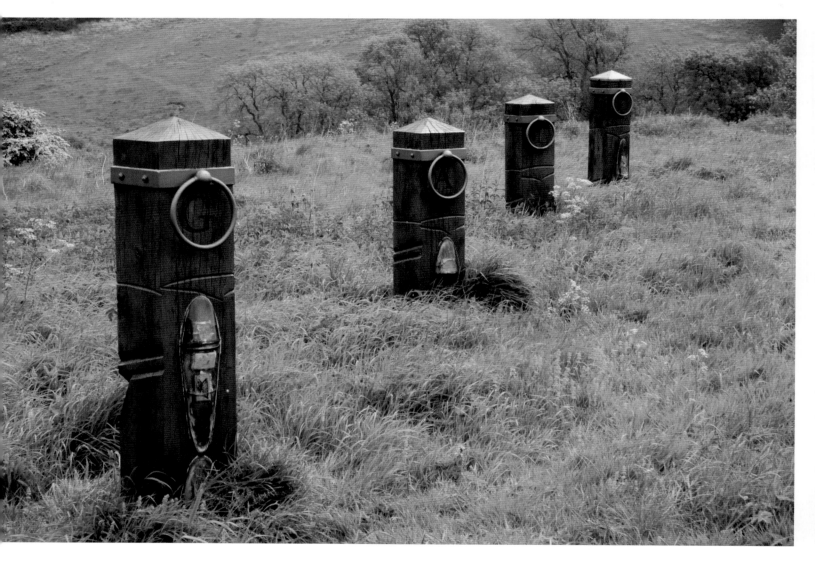

Part of the Way Post Sculptures
This group of Way Posts spells out the word 'G.A.I.T' which refers to the units of common
grazing which were let on Millington Pastures before it was enclosed by fencing.

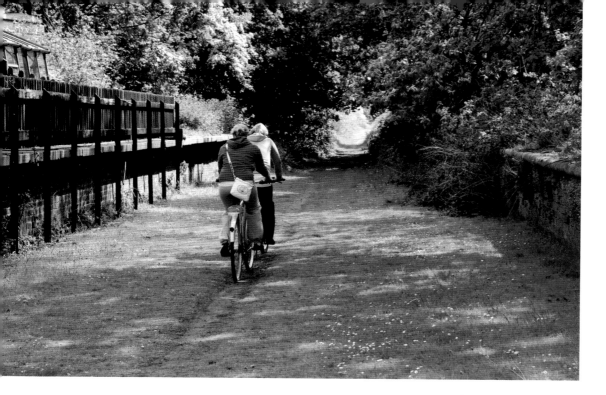

Hudson Way
Cyclists enjoy the Hudson Way, an 11 mile trail between Market Weighton and Beverley that follows the route of the former railway, and which was named after George Hudson, the 'Railway King' and one-time owner of the Londesborough estate.

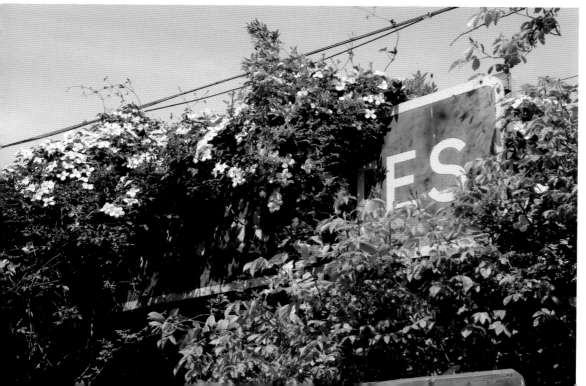

Kiplingcotes station
Flowering clematis has almost smothered the sign on the old platform of Kiplingcotes station which was built to serve local farms and for the use of Lord Hotham of nearby Dalton Hall.

Eleanor Cross at Sledmere
This memorial was commissioned by Sir Tatton Sykes in 1895 and it is a reproduction of one of the original Eleanor Crosses that date from 1291; these being erected to mark the resting places for the cortege that carried the body of Edward I's queen, Eleanor, from Harby, near Leicester to Westminster Abbey. The monument was later dedicated to men from the Sledmere Estate who died during the First World War, and to Sir Mark Sykes who died in the influenza epidemic of 1919.

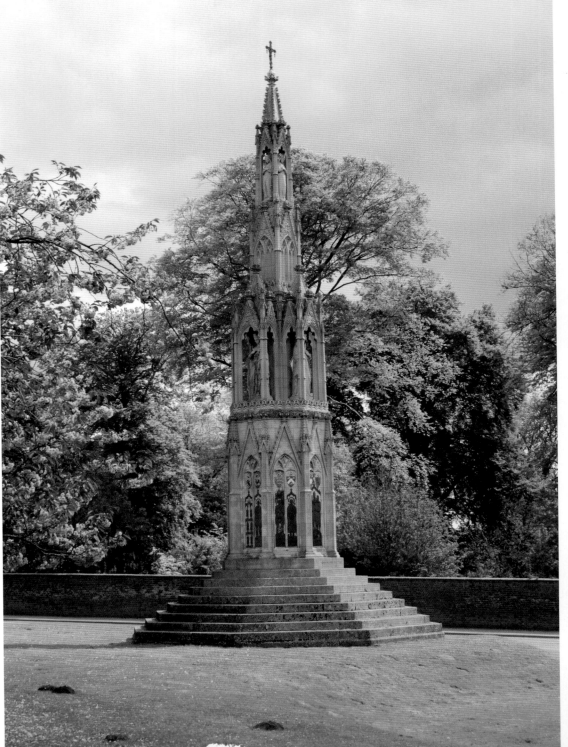

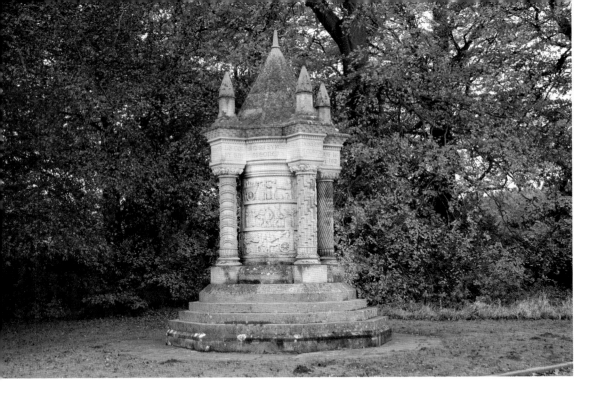

**Wagoners' Memorial
at Sledmere**
The activities of the volunteer corps of Wagoners, men from the Wolds who were skilled in driving horse and pole wagons, are illustrated around this memorial which was designed by Sir Mark Sykes. The Wagoners provided horse-drawn supply transport to soldiers in the trenches during the First World War.

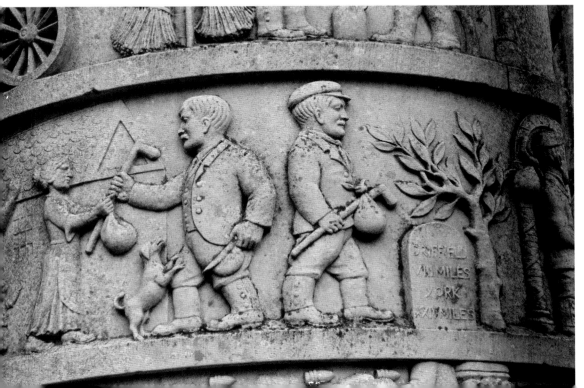

This close-up view shows a farm worker leaving his home and family to join the Wagoners' Reserve.

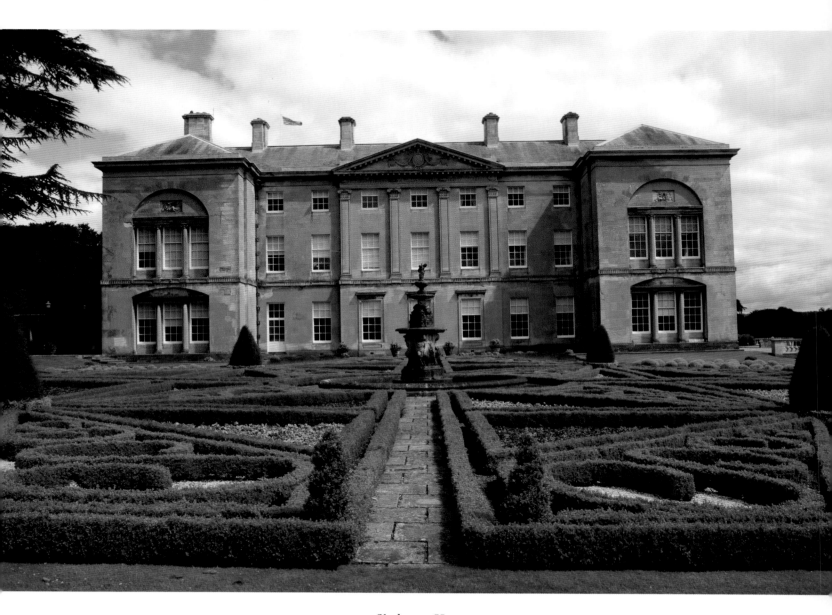

Sledmere House

The house has been the home of the Sykes family since the mid eighteenth century, but the present building dates from the extensive restoration which followed a serious fire in 1911.

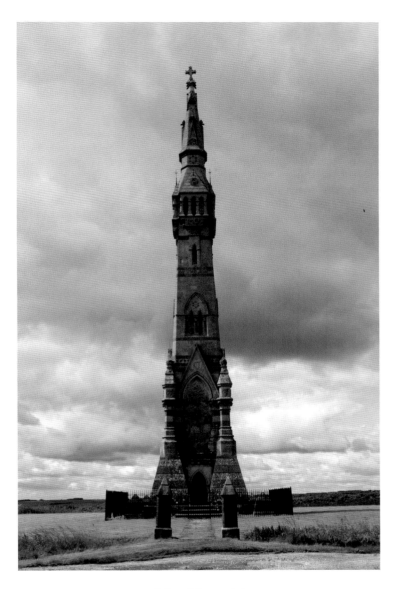

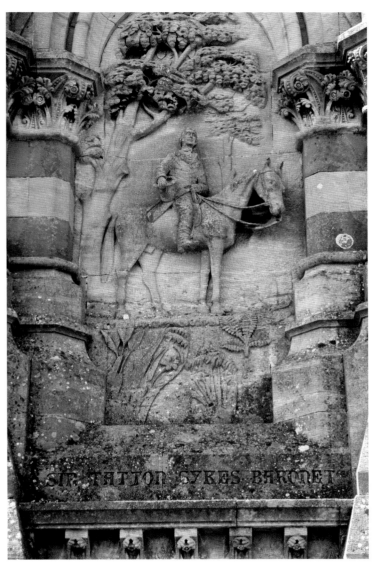

Sykes Memorial
Raised in 1865, this monument commemorates the life and work of Sir Tatton Sykes. It stands 37 metres or 120 feet high on the summit of Garton Hill and is a major landmark on the Wolds.

The carved relief of Sir Tatton Sykes, fourth baronet (1772–1863), on horseback, can be seen on one side of the stone memorial.

The Villa, Sledmere
Built in the late nineteenth century for the Clerk of Works this house forms part of the distinctive estate village style.

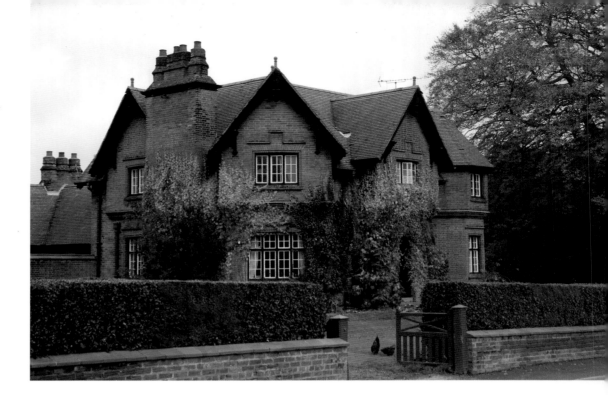

The Shop Farmhouse, Sledmere
This house and former butcher's shop dates from the late eighteenth century and is built in local brown brick with a pantile roof.

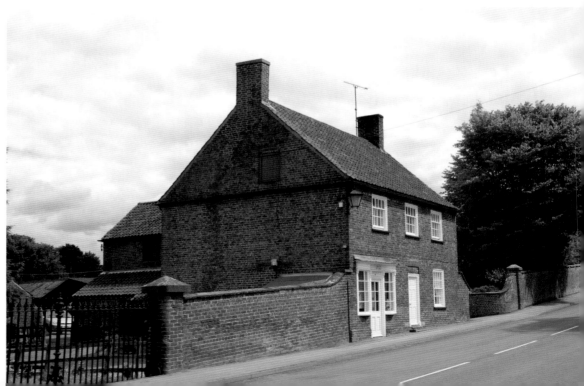

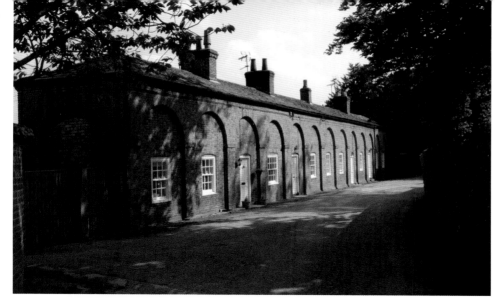

Left:
Gardeners' Row, Sledmere
The terrace of four single-storey cottages adjoins the walled garden and would originally have housed the estate gardeners.

Below:
The Well, Sledmere
This monument was erected by Sir Tatton Sykes in 1840 in memory of his father Sir Christopher Sykes who was responsible for much building work and agricultural improvements to the estate. The rotunda originally housed the village well.

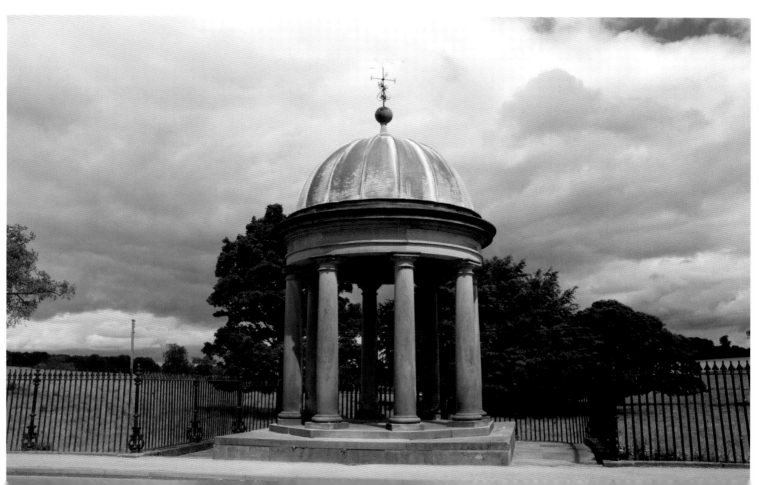

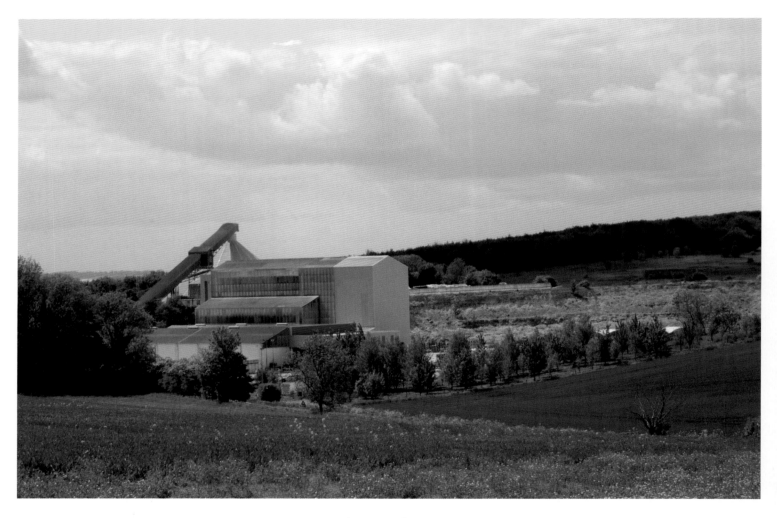

Welton Wold Quarry
Here are the modern buildings associated with a working chalk quarry.

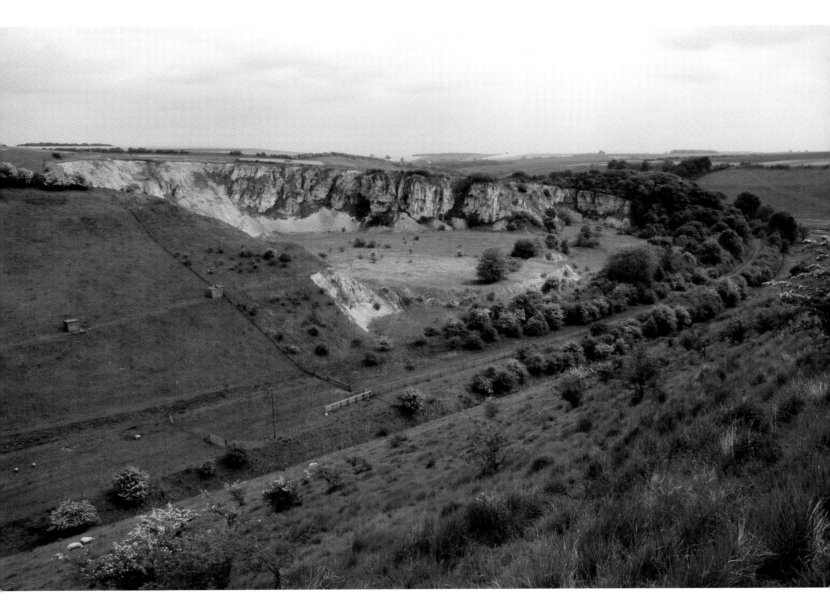

Burdale Quarry

This former chalk quarry has been disused since 1955 but the route of the old Malton to Driffield railway line can still be seen. Trains took the quarried stone to the iron and steel works on Teesside.

The Wolds Way

This plaque on the wall of Londesborough churchyard marks the route of the Wolds Way, a National Trail, 79 miles long, that stretches the length of the Wolds from Hessle in the south to Filey in the north.

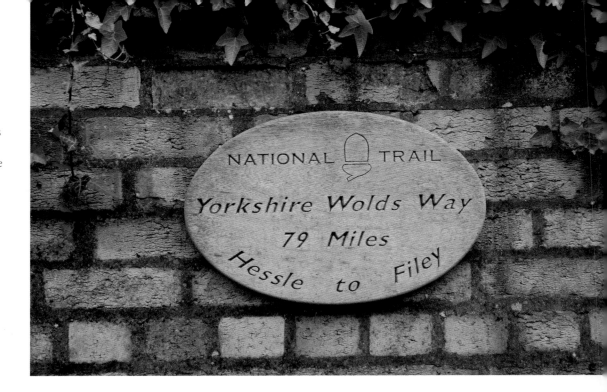

Signposts mark the route of the Wolds Way; this one is in the park at Londesborough. The grand house associated with the park has long gone, but in the background is a brick retaining wall with twelve giant round arches. The arches were said to provide shelter for deer in the park while the wall supported a large flat terrace that formed part of the formal garden to the hall.

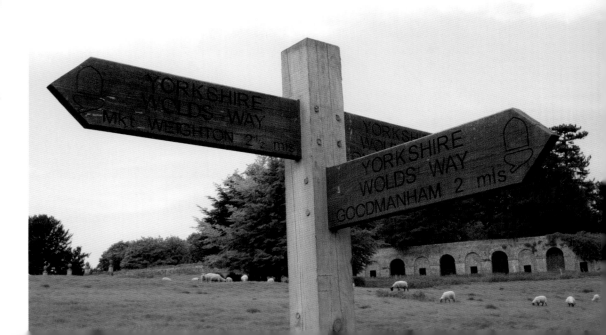

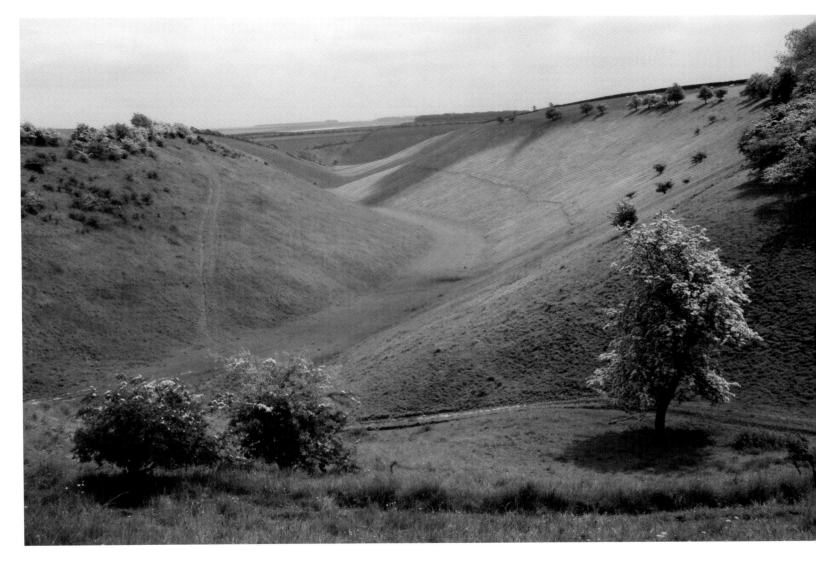

Holm Dale, near Fridaythorpe

These steep-sided dry valleys are a feature of the Wolds, and here the Wolds Way follows the valley bottom.

Wharram Percy
The deserted medieval village of Wharram Percy was extensively studied by archaeologists between 1950 and 1990 and they used this eighteenth century farm building as their hostel and headquarters.

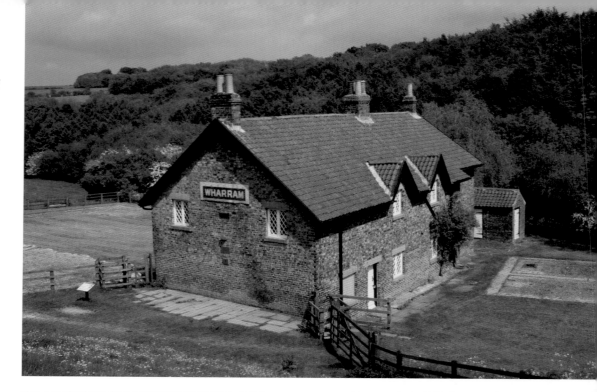

The station sign, Wharram Percy
The sign was originally on the platform of the nearby station but it was taken down during the Second World War when all signs were removed in an effort to confuse the enemy should there be an invasion. The sign was never re-instated although the station continued in use until the 1950s. It was later found, restored and hung on the cottages by the excavators of Wharram Percy.

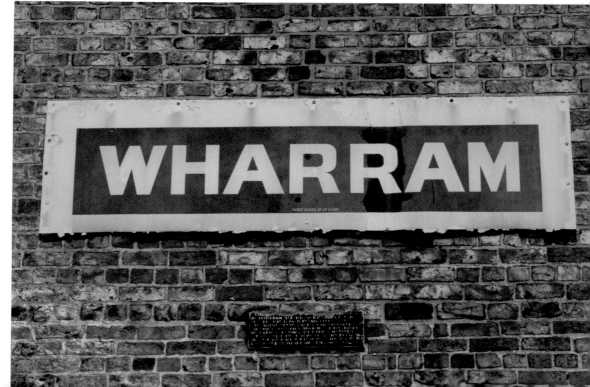

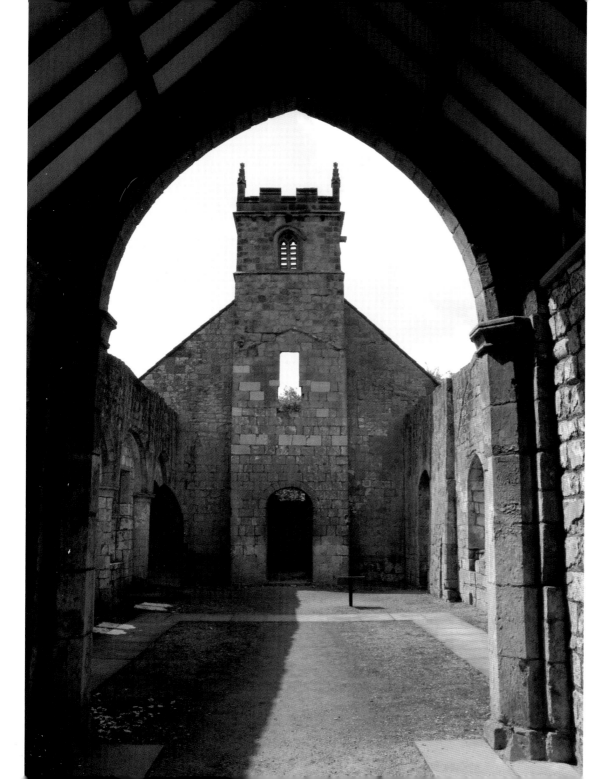

St Martin's church, Wharram Percy
The last regular service was held in this church in 1949 and the fittings were removed in 1954. By the 1970s the roof had gone and the church is now a maintained ruin under the care of English Heritage.

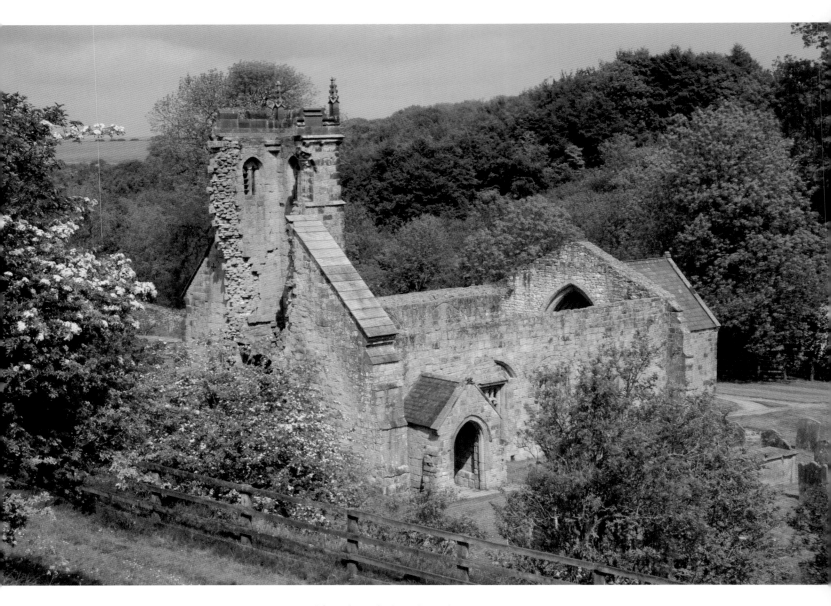

Abandoned church, Wharram Percy

Excavations have revealed the complicated history of this church, from its beginnings in the tenth or eleventh century through various phases of rebuilding, growth and then decline, as it served first the parishioners of Wharram Percy and then of nearby Thixendale.

Earthworks, Wharram Percy
The 'lumps and bumps' on the dale side reveal the outlines of the house plots of the village
that flourished during the twelfth to the fourteenth centuries, only to be deserted around 1500.

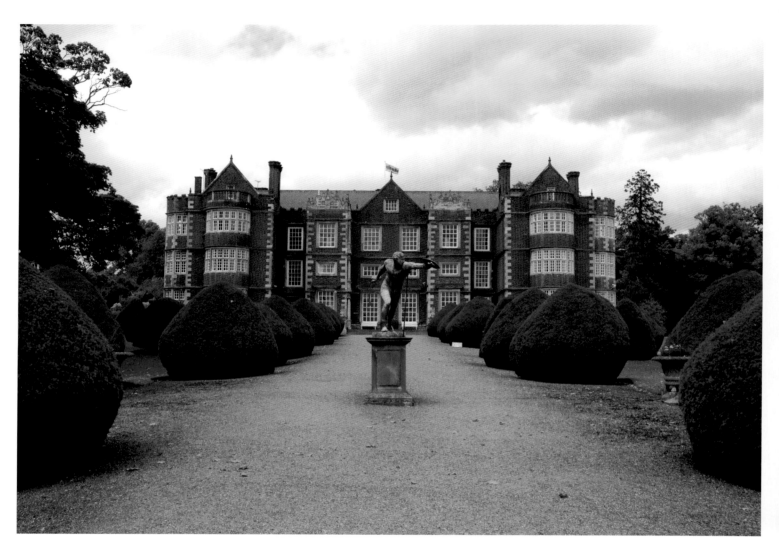

Burton Agnes Hall

The house is a superb example of Elizabethan architecture and it is famous for its seventeenth-century carvings.
The historic rooms are further enhanced by a fine collection of modern paintings, bronzes, furniture and porcelain.

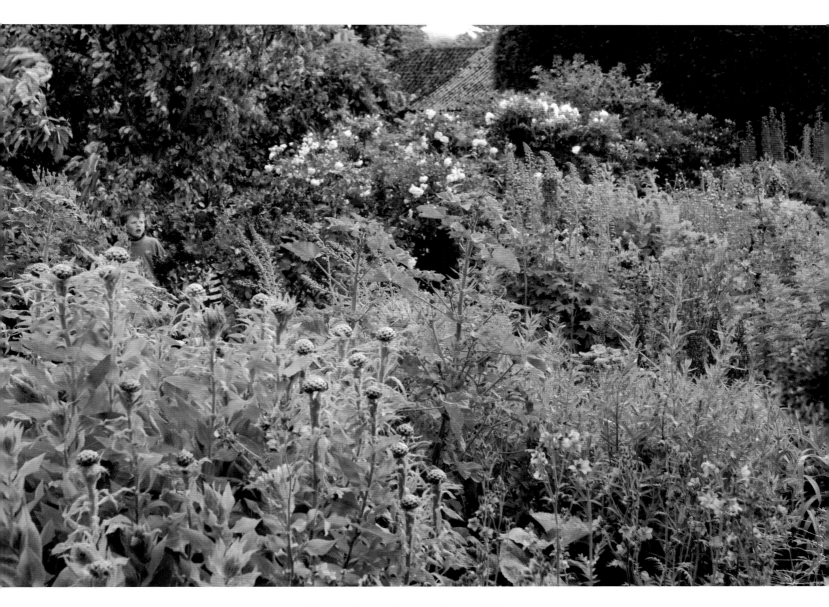

The garden at Burton Agnes Hall
In recent years the old walled garden has been transformed with sumptuous
herbaceous borders, a scented garden, herbs and a collection of shrub roses.

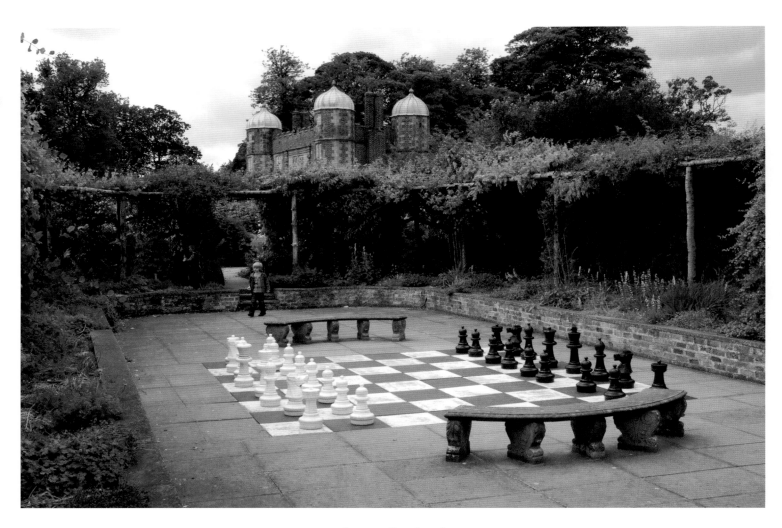

Anyone for chess?

Or a game of draughts?
Within the walled garden there are giant board games which invite visitors to take part.

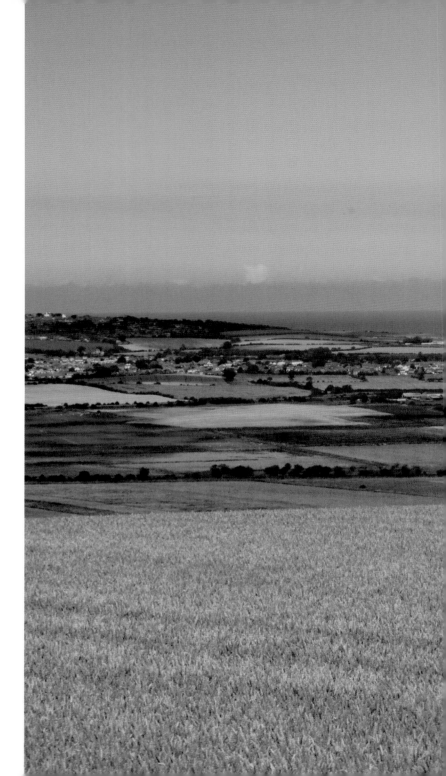

A view from the northern edge
of the Wolds towards Cayton Bay

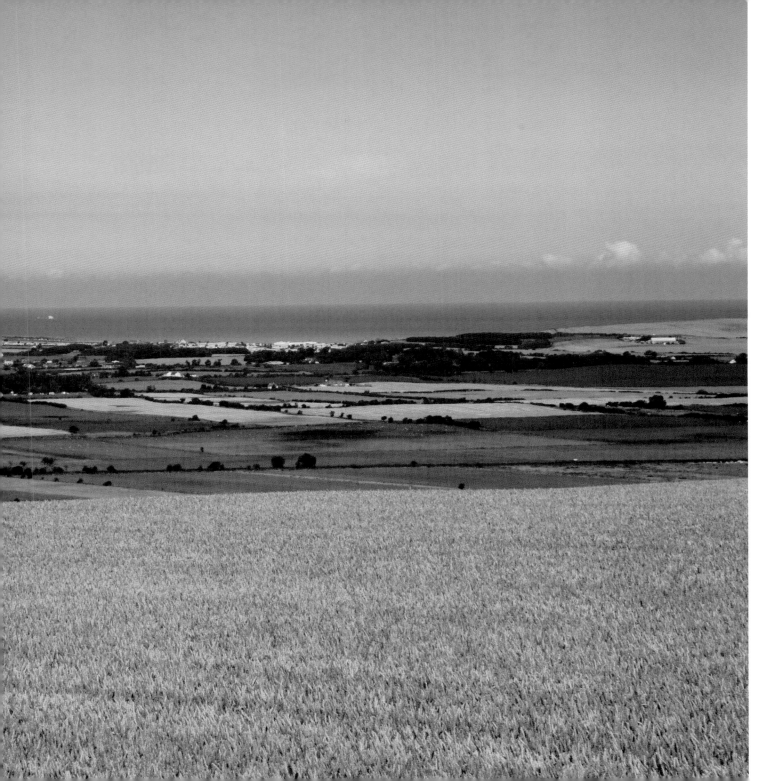

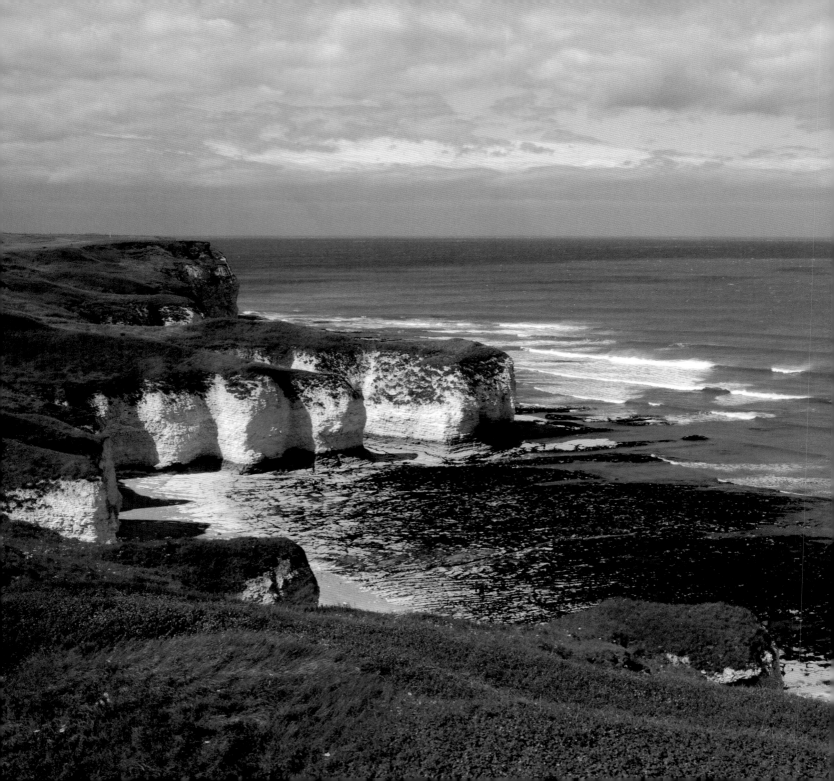

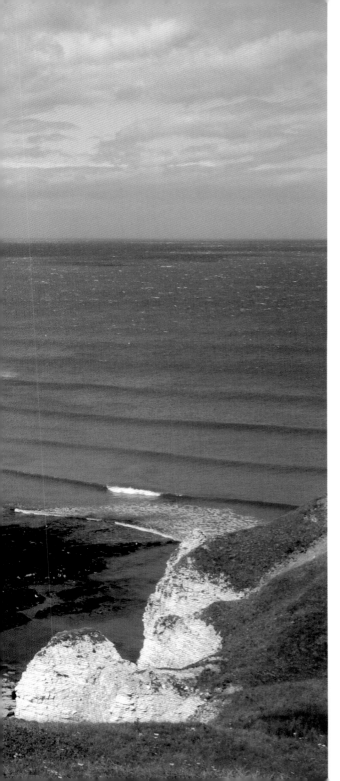

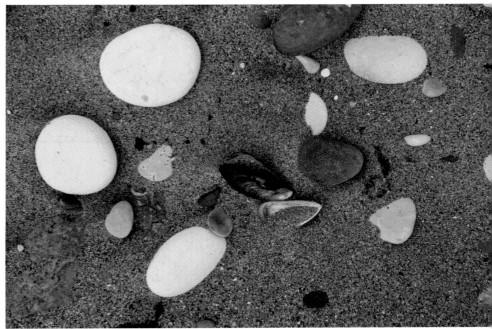

Above:
Pebbles and shells
Amongst the sand and shells are white pebbles of chalk, eroded from the cliffs
where the Wolds meet the sea.

Left:
Selwicks Bay, Flamborough Head
The tide is out revealing the black-seaweed-covered rocks below the white
chalk cliffs that surround this pretty little cove.

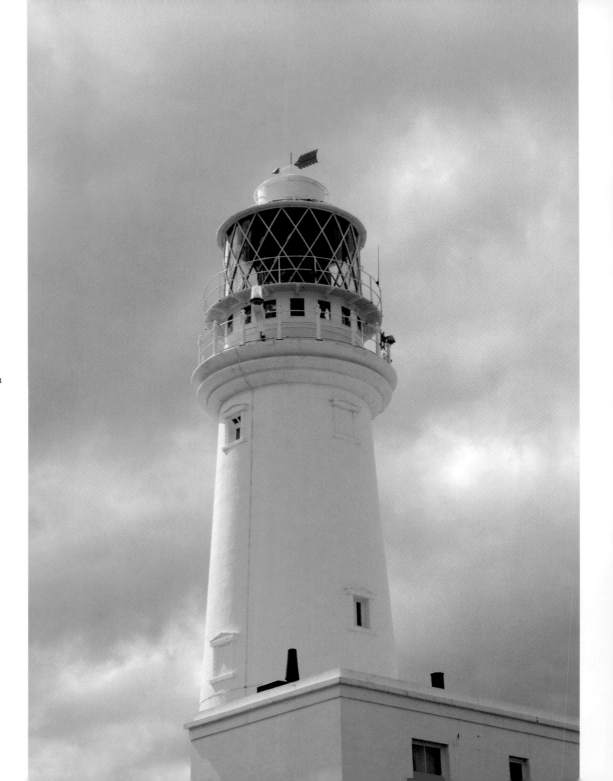

Flamborough Head lighthouse
This is the 'new' lighthouse, built in 1806, which has been sending out its warning beacon to passing ships for over 200 years.

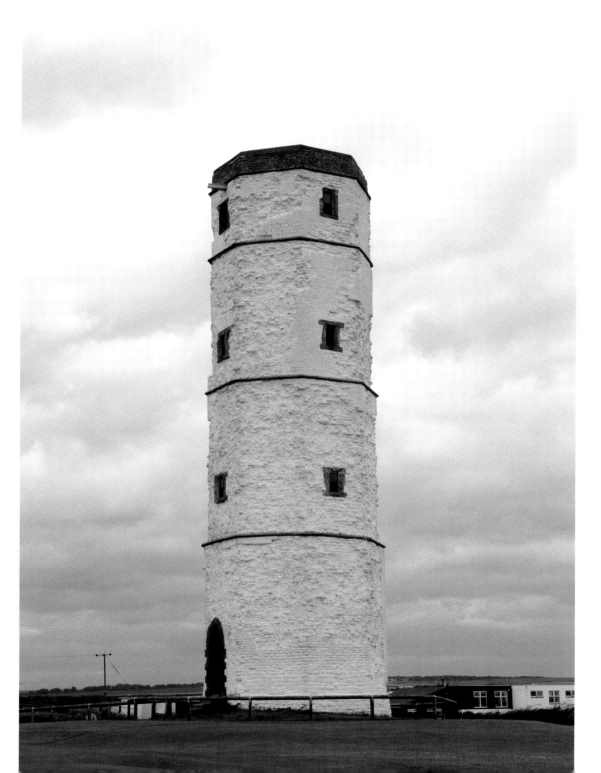

**The Old Lighthouse,
Flamborough Head**
Built in 1674 this octagonal
tower was a private venture
and, despite its name, it has
never functioned as a
lighthouse.

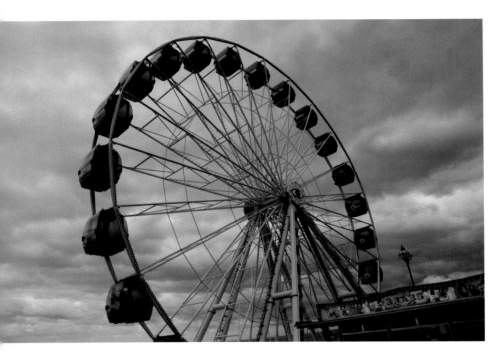

Above:
Bridlington Eye
This huge observation wheel gave visitors
stunning views along the coast.

Right:
South Sands, Bridlington
As the tide retreats a vast expanse of sand is revealed with
plenty of space for walking, paddling or building sandcastles.

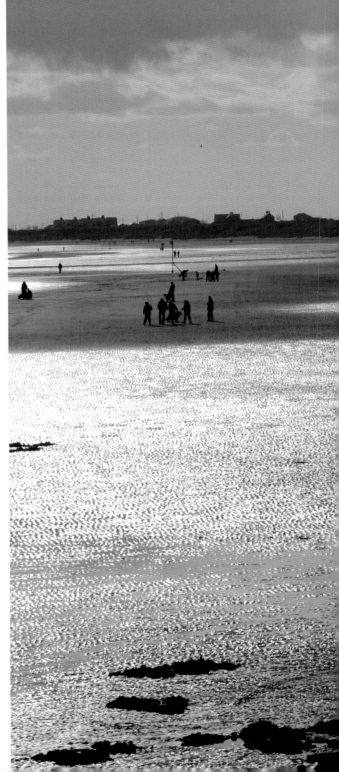

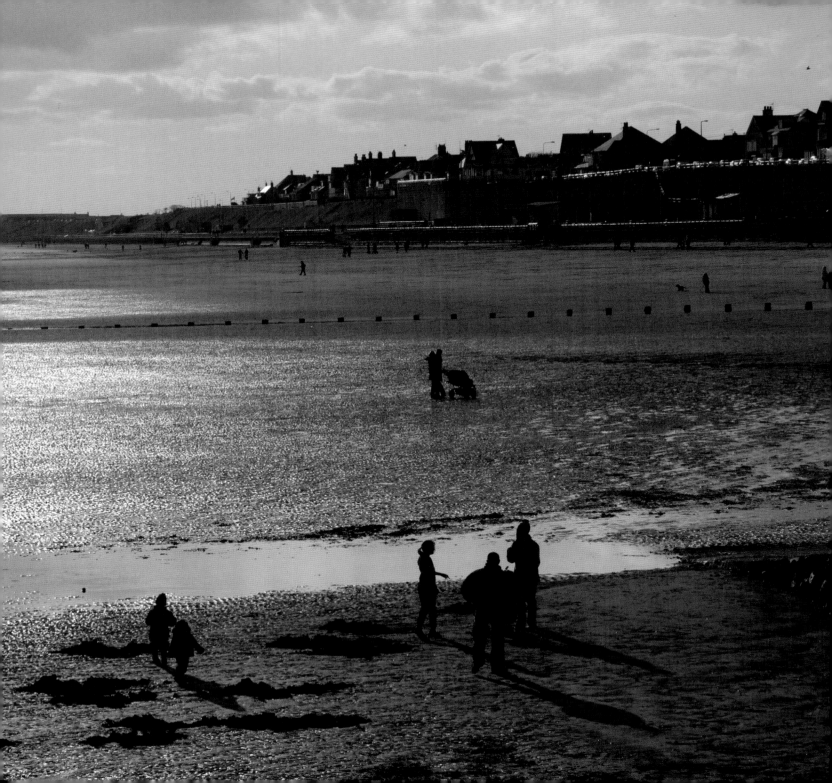

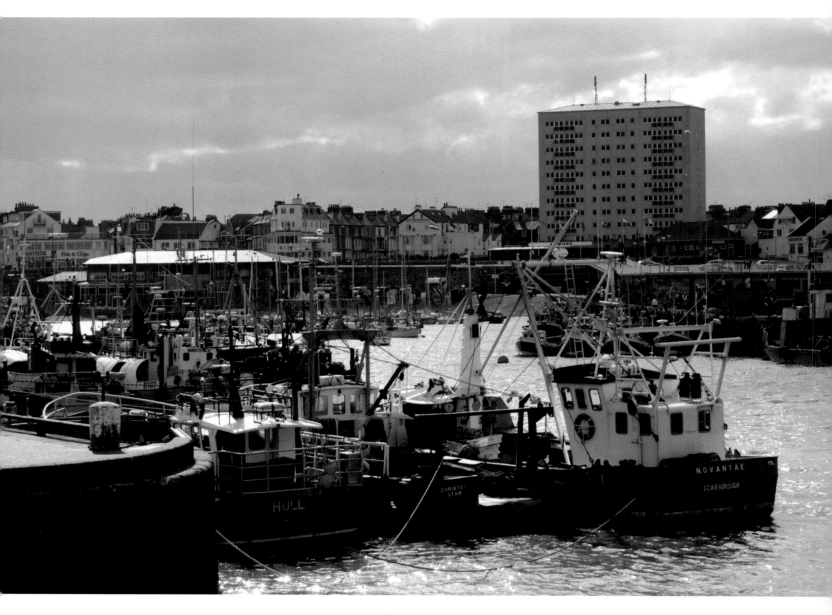

Bridlington harbour
The harbour provides a sheltered mooring for fishing and pleasure boats.

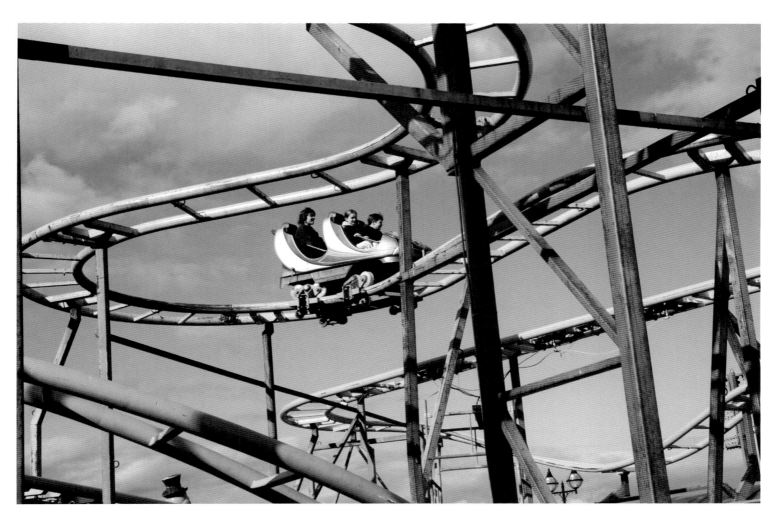

Funfair, Bridlington
The funfair offers an exhilarating ride for the young-at-heart.

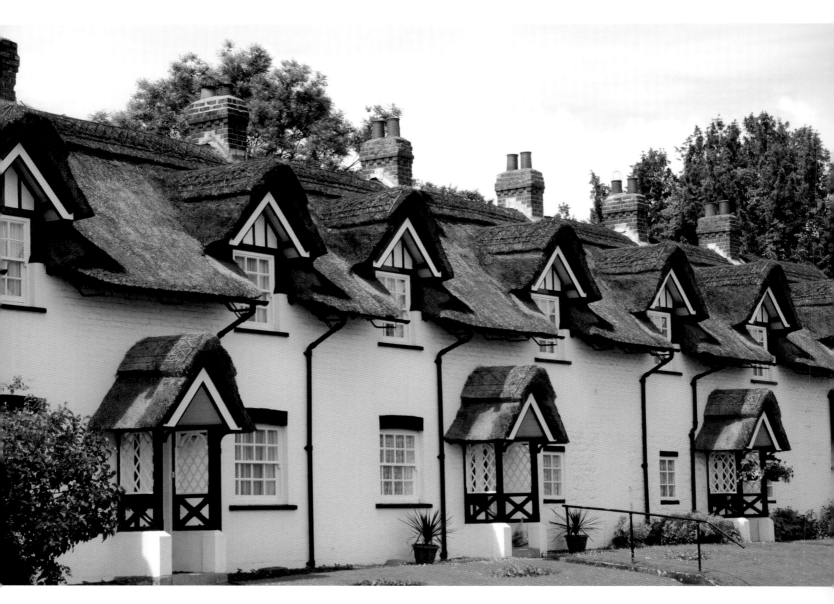

Thatched cottages at Warter
This picturesque row of cottages that faces onto the triangular Cross Green
was created in the 1930s but they give the appearance of being much older.

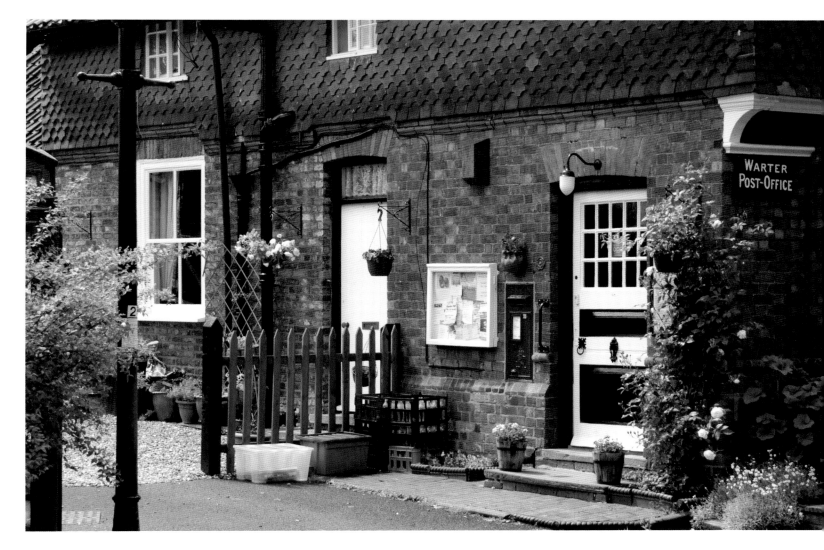

The Post Office, Warter

Many of the houses in Warter were built as an estate village in the late Victorian period;
the Post Office and shop occupies one of these properties.

St James' church, Warter
This redundant church has been saved by the Yorkshire Wolds Buildings Preservation Trust and it has a new role as the Yorkshire Wolds Heritage Centre.

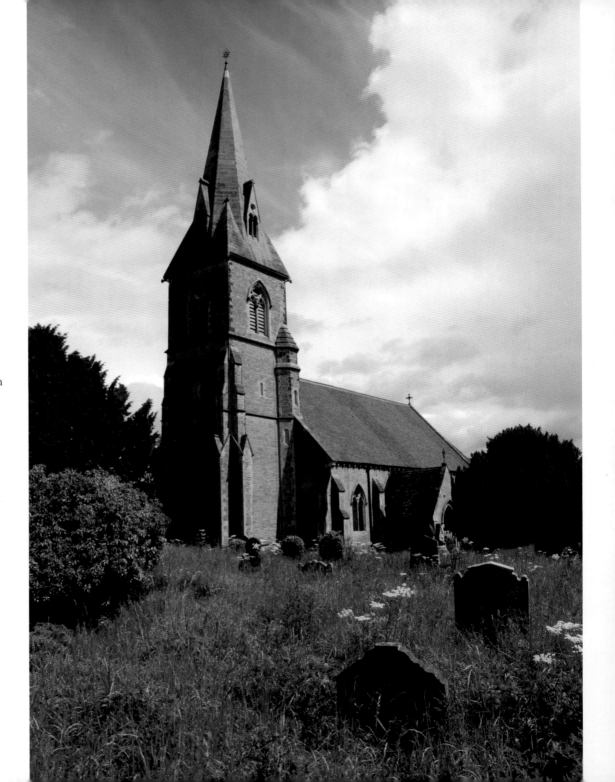

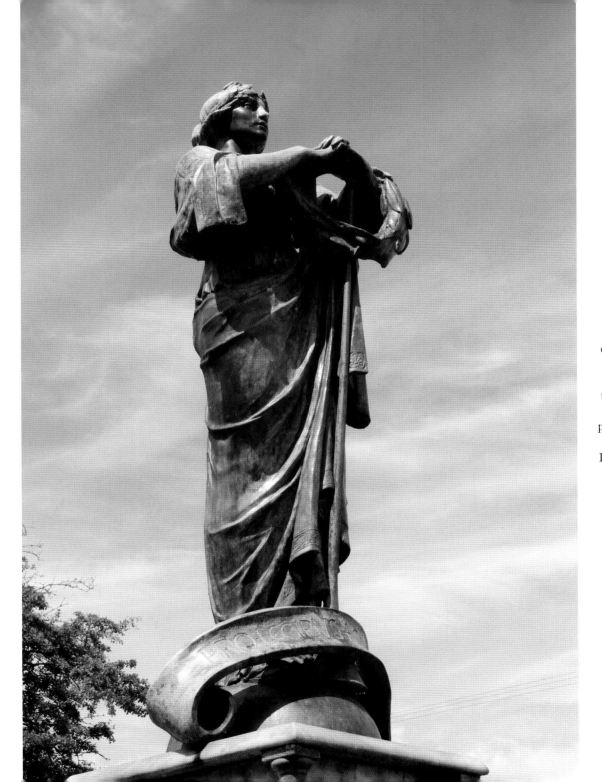

Monument in the churchyard at Warter
Both the church and churchyard at Warter contain some superb Edwardian monuments to members of the family of Charles Wilson, a shipping magnate who purchased the Warter estate in 1878, and who was created Lord Nunburnholme in 1906.

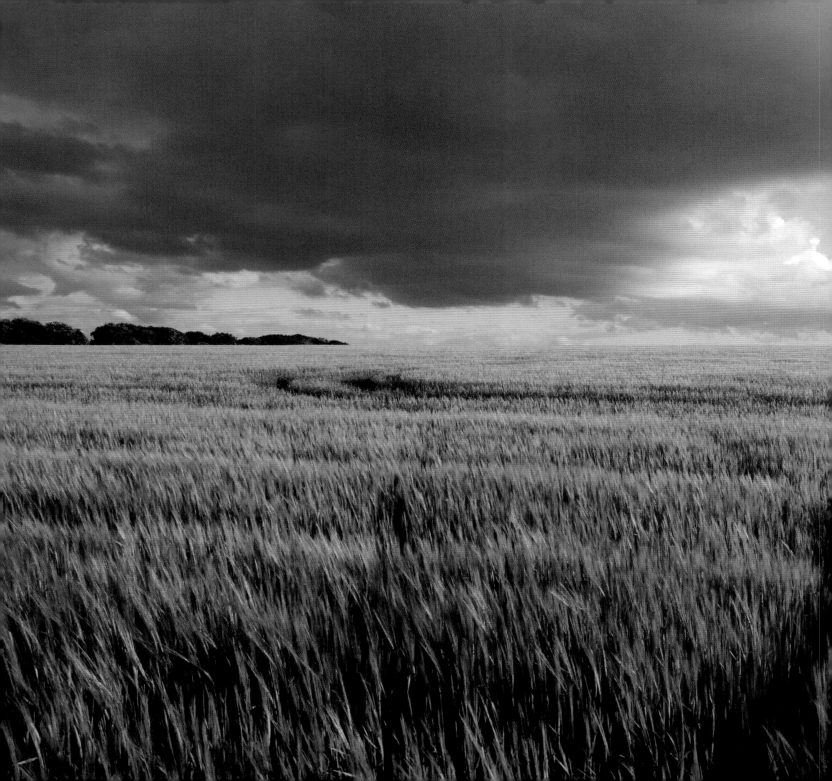

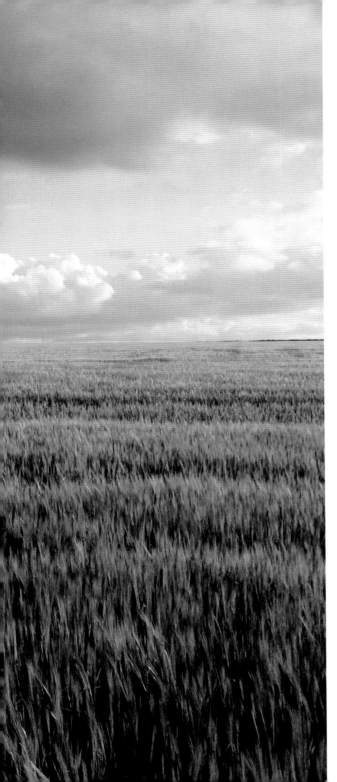

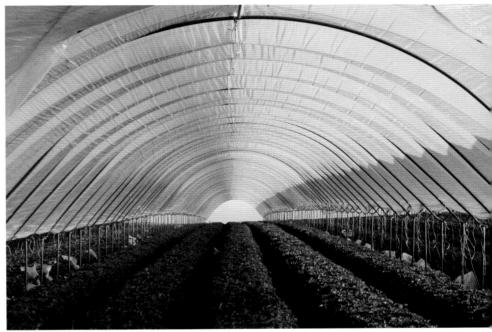

Above:
Polytunnel near Huggate
A crop of sweet juicy strawberries ripens under
the protective polythene covering.

Left:
Barley field near Warter
Rich light catches the waving heads of
barley as storm clouds pass overhead.

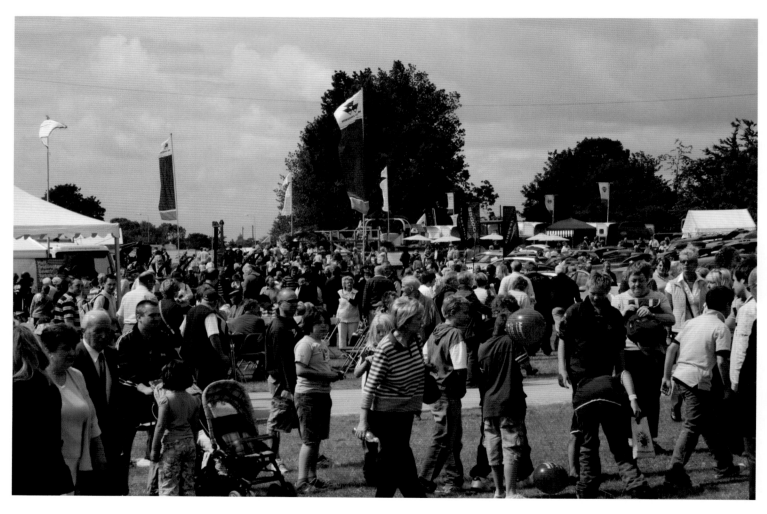

Visitors to Driffield Show
Visitors flock to this popular agricultural show which is held each year in July.

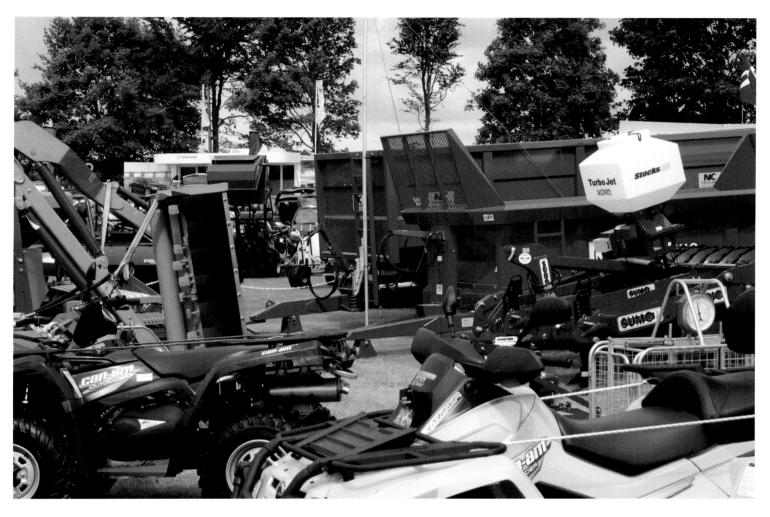

Display of agricultural machinery
Red, blue, orange and yellow; colourful, shiny and new, will anyone be tempted to buy?

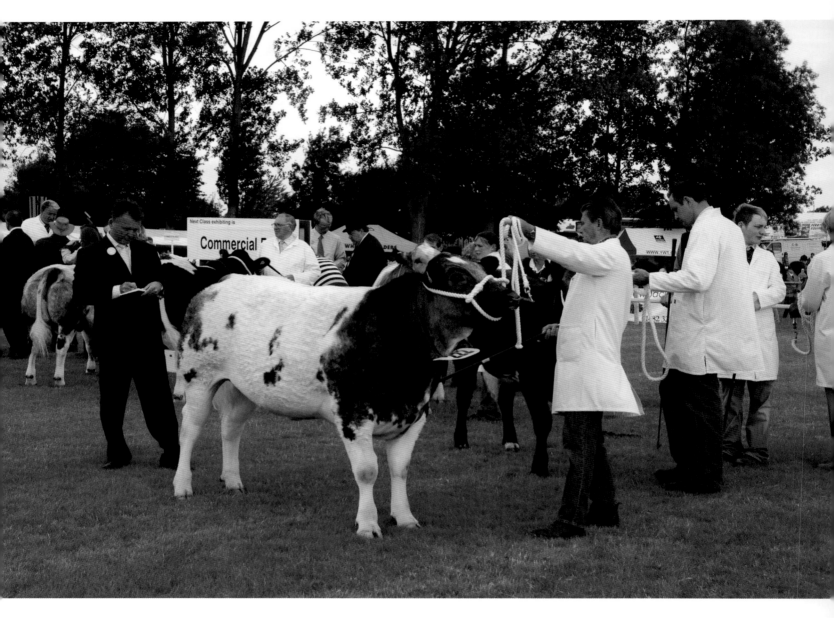

Cattle judging at Driffield Show
There are classes for cattle, sheep, pigs and horses at the show, as farmers and breeders compete for the top awards.

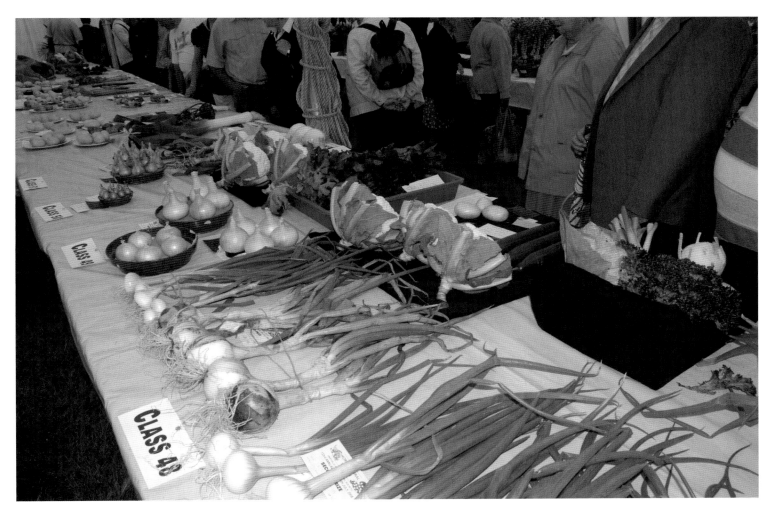

Vegetable exhibits at Driffield Show
Keen gardeners display their produce in the hope of winning a prize.

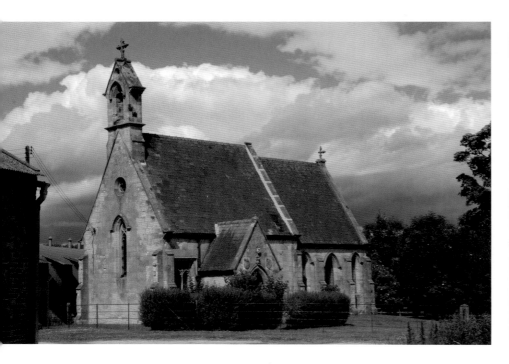

Above:
St Mary's church, Cowlam
A small church stands alone amongst modern farm buildings,
the village having been abandoned in the seventeenth century.

Right:
Cinquefoil Brow and Elvin Lear
The grassland in this dry valley near Cowlam
is full of wild flowers and butterflies.

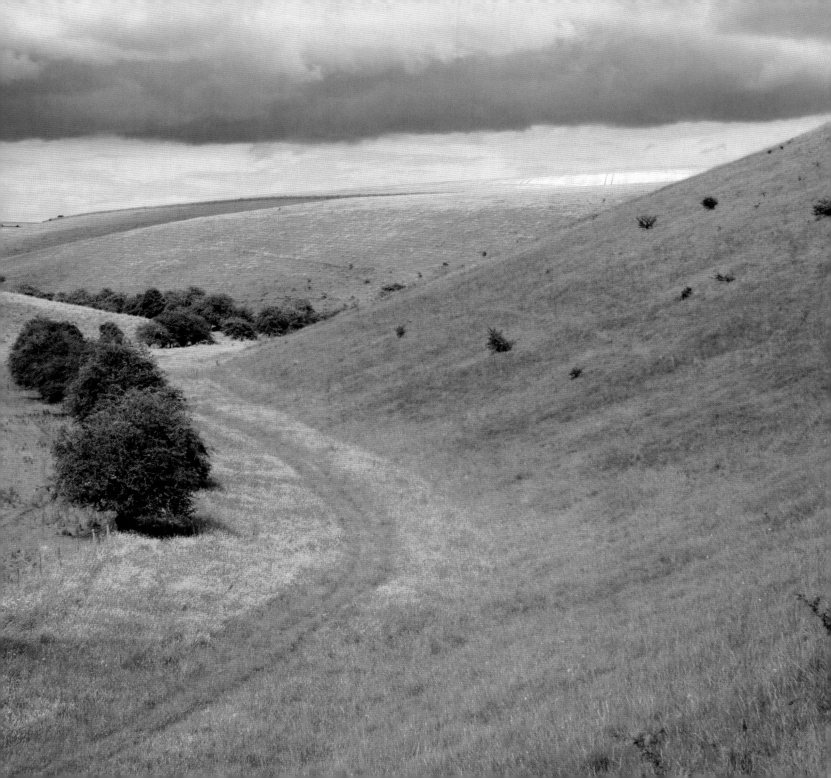

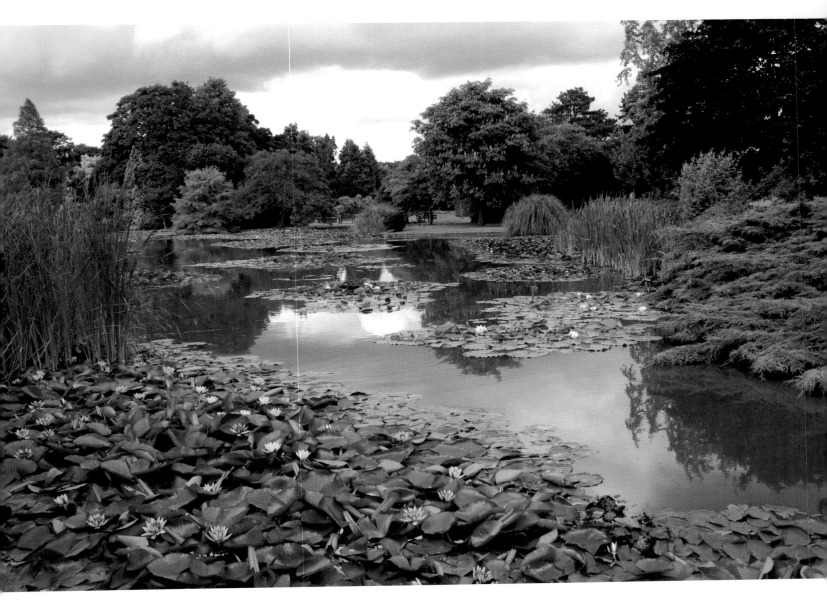

Burnby Hall Gardens, Pocklington

The lake with its wonderful displays of water lilies and shoals of greedy carp is the highlight of these gardens which were created by Major Stewart and his wife and left to the people of Pocklington to enjoy after their deaths.

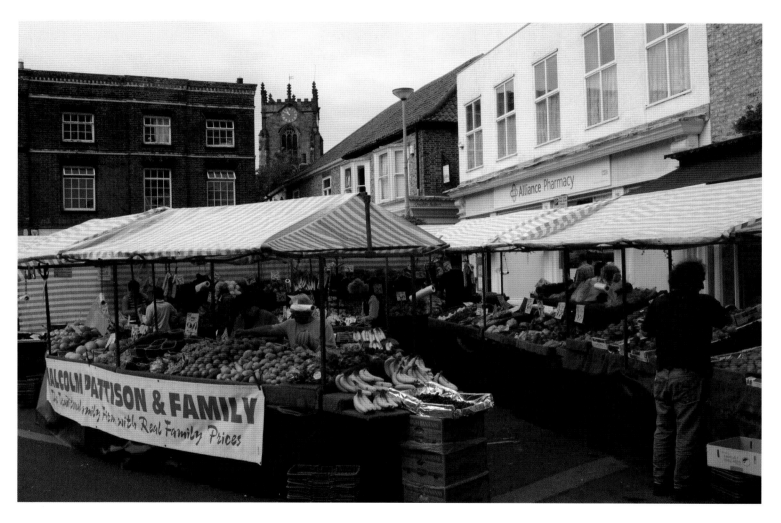

Market day at Pocklington
Pocklington, on the western edge of the Wolds, has markets on Tuesday and Saturday
each week, which draw in people from the surrounding area to do their shopping.

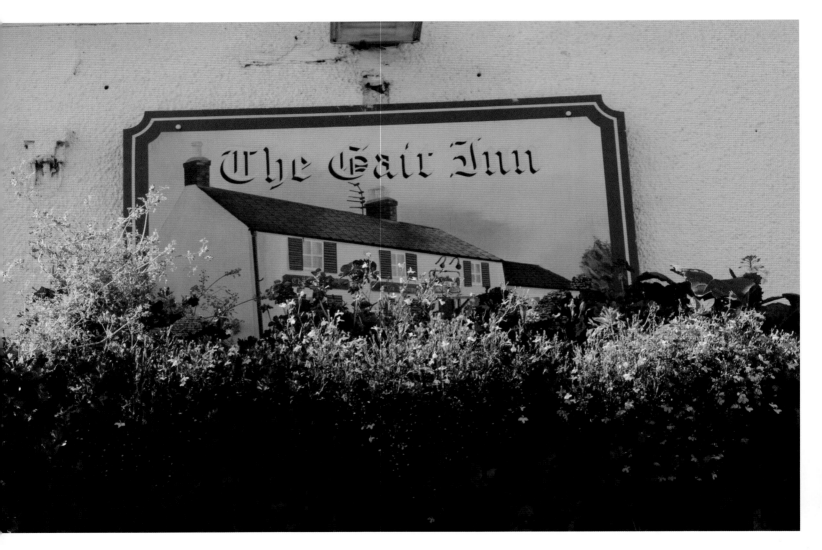

The Gait Inn, Millington
Named after the 'gaits' which were units of grazing on the open village
pastures, this traditional country pub is in the village of Millington.

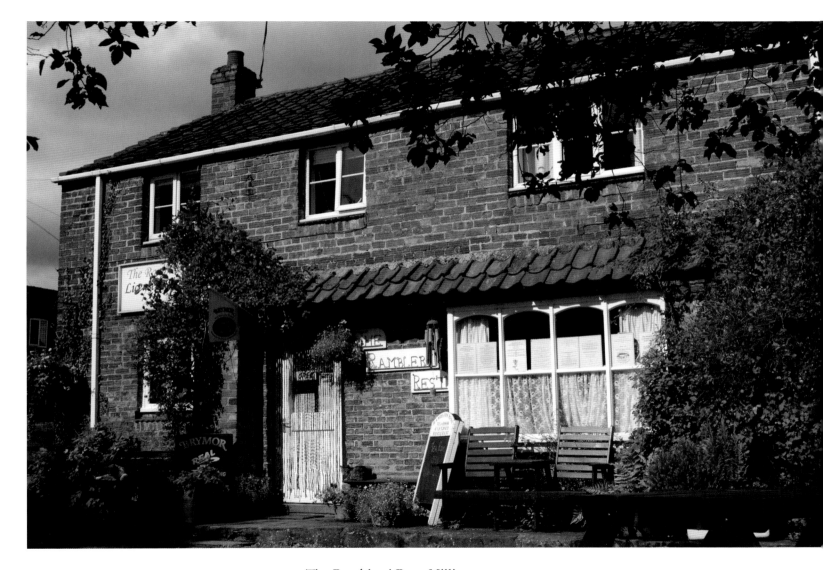

The Ramblers' Rest, Millington
Serving cream teas and light lunches this café is popular with walkers and cyclists exploring the local area.

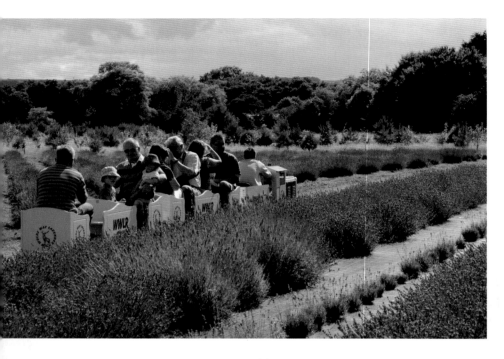

Above:
Narrow gauge railway at Wolds Way Lavender
The young and old enjoy a ride on the railway at Wolds Way Lavender which
is also used to bring in the lavender from the fields during the harvest.

Right:
Lavender fields, Wolds Way Lavender
The Wolds Way passes close to the lavender
farm and distillery at Wintringham.

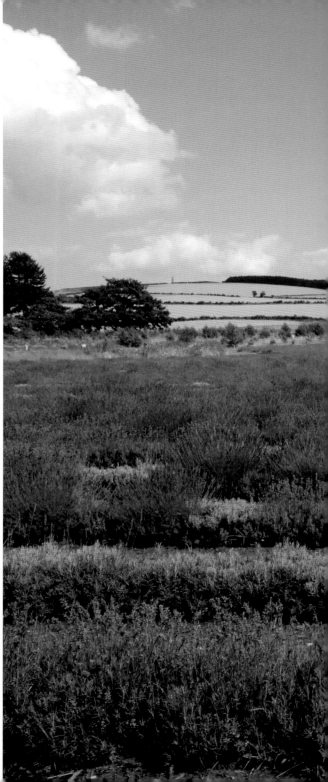

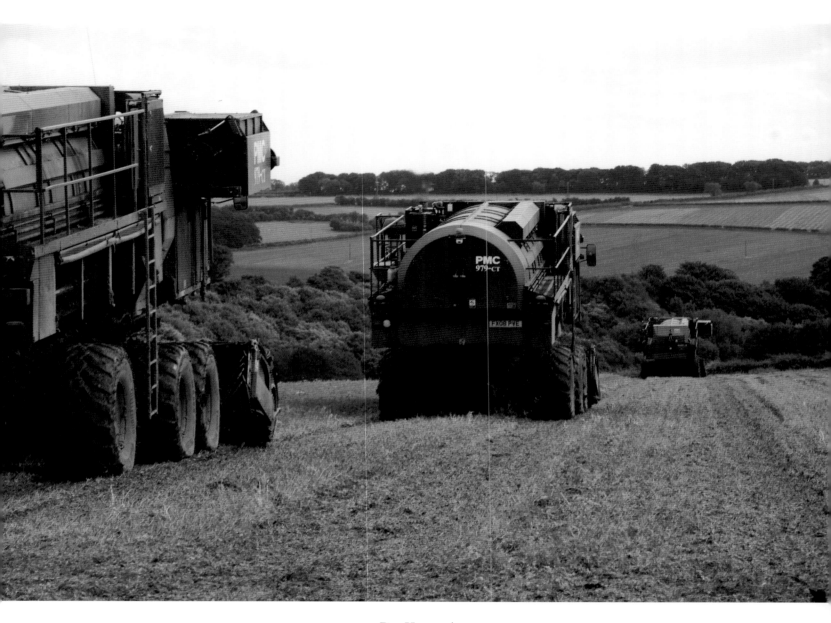

Pea Harvesting
Three massive pea harvesting machines make short work of the pea crop in this field near Warter.

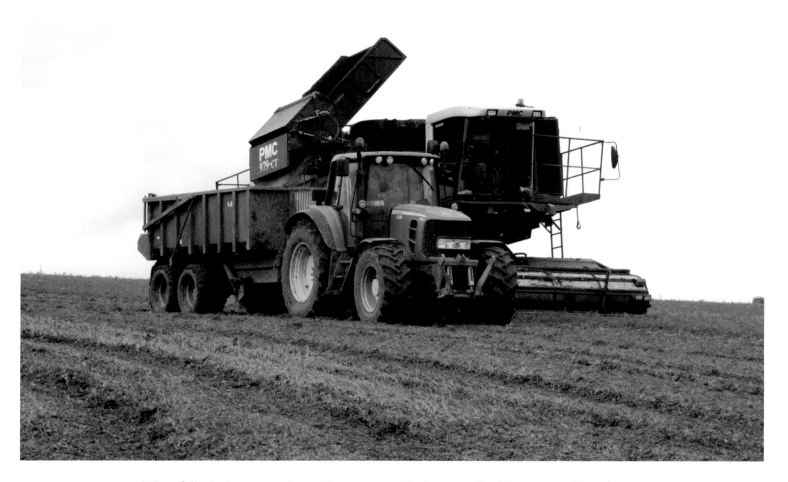

When full, the hopper on the pea harvester empties into a trailer. The peas are then taken to waiting lorries and rushed to the factory at Hull for freezing before there is any loss in their quality.

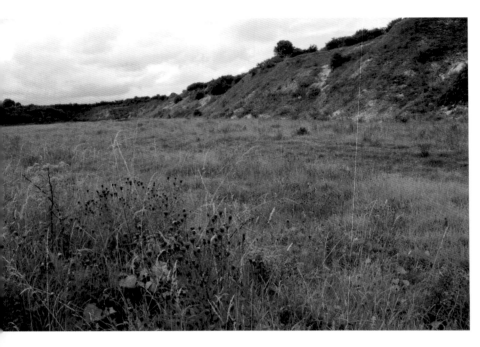

Above:
Wharram Quarry
The flat quarry floor supports a stunning range of specialist chalkland
plants under the protection of the Yorkshire Wildlife Trust.

Right:
The nature reserve sign

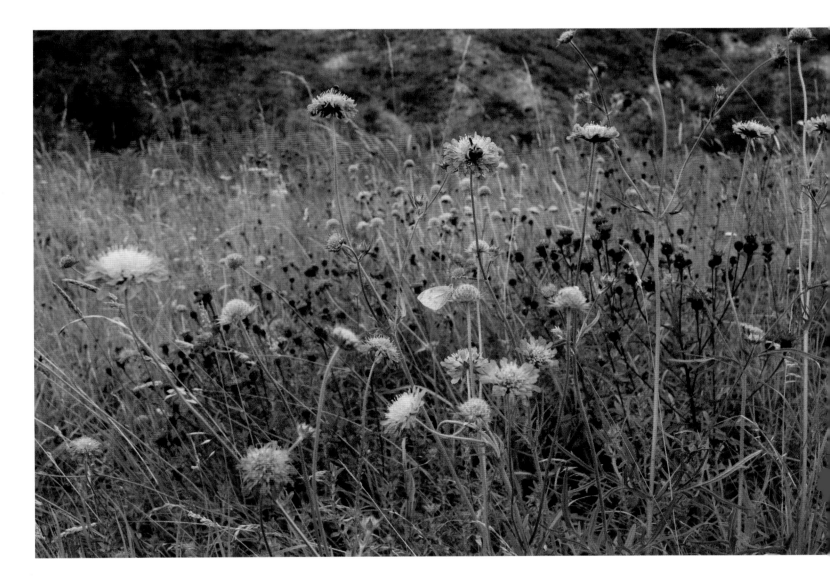

A marbled white butterfly feeds on the flowers of field scabious and knapweed.

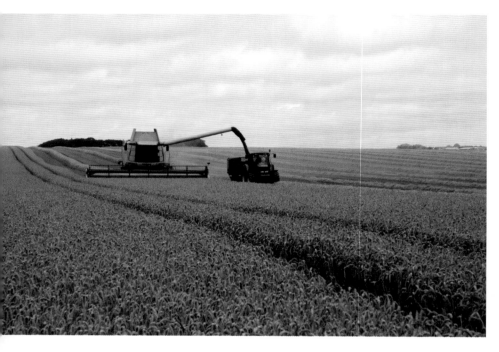

Above:
Harvesting scene
In late summer the corn harvest begins and huge modern combine harvesters
are at work on the large fields that stretch across the top of the Wolds.

Right:
Goodmanham Wold
A bare field of chalky soil awaits the next crop.

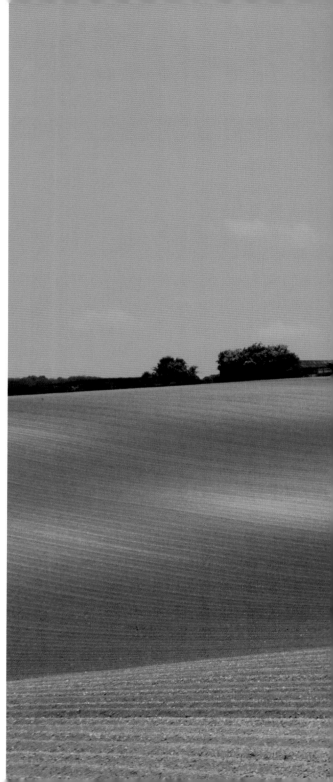

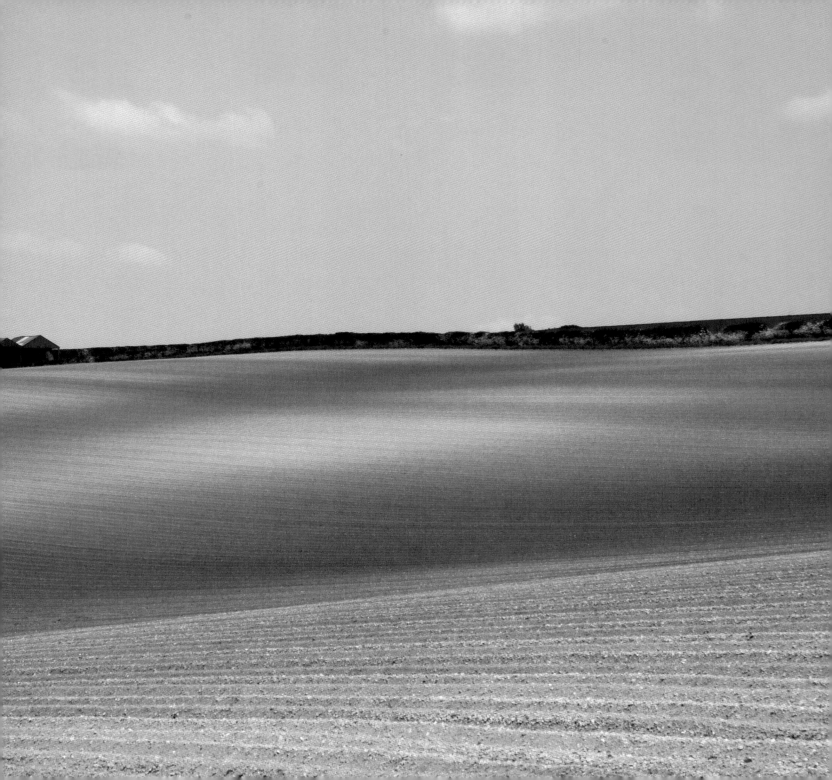

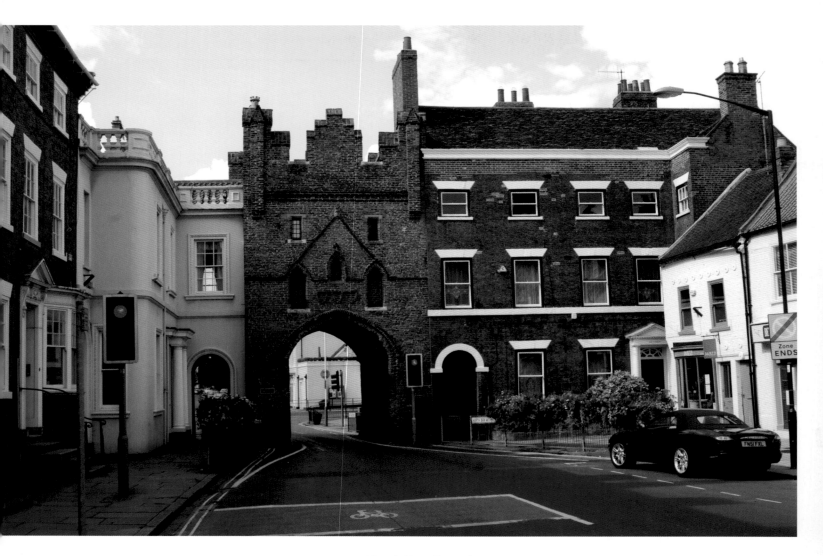

North Bar, Beverley

In medieval times all the main entrances to the town would have been guarded by gatehouses.
The North Bar is the only survivor and it is a very important example of early brick construction.

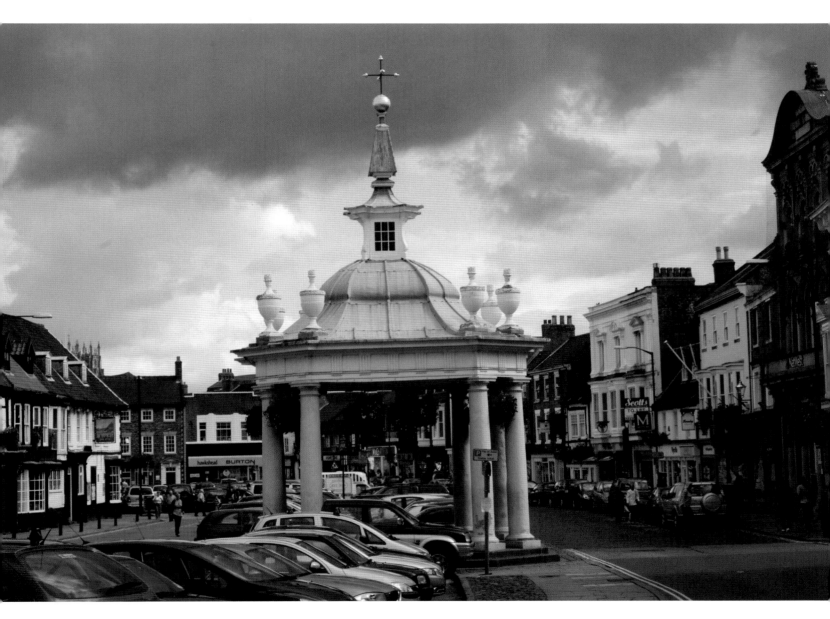

Market Cross, Beverley
A summer storm approaches and the rich light sets off the very handsome Market Cross, the focal point of Saturday Market in the town.

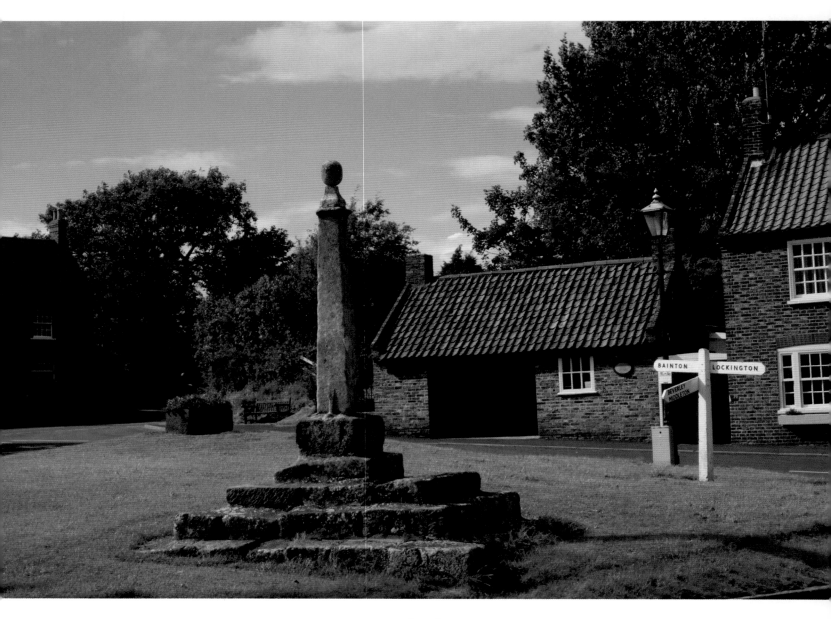

Lund
The village green at Lund has a market cross which indicates that it once hosted
a weekly market. The restored blacksmith's workshop makes a useful shelter.

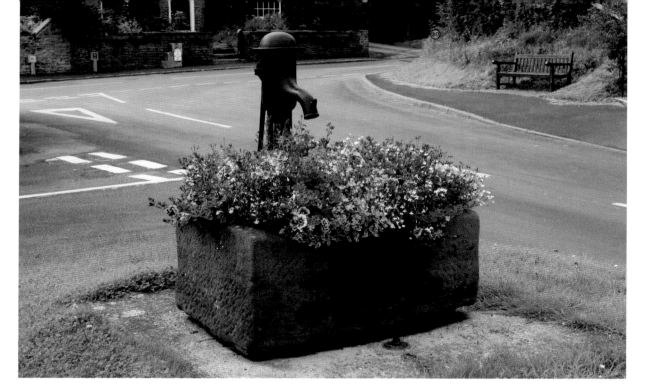

The pump and flower-filled trough at Lund.

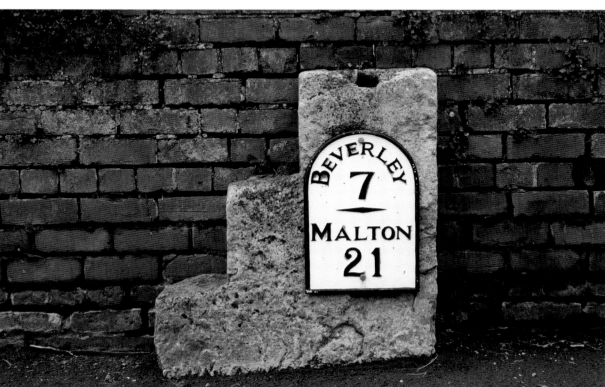

Milestone
The milestone shows that it was 7 miles to Beverley and 21 miles to Malton when the main road went through the village, but it has now been by-passed.

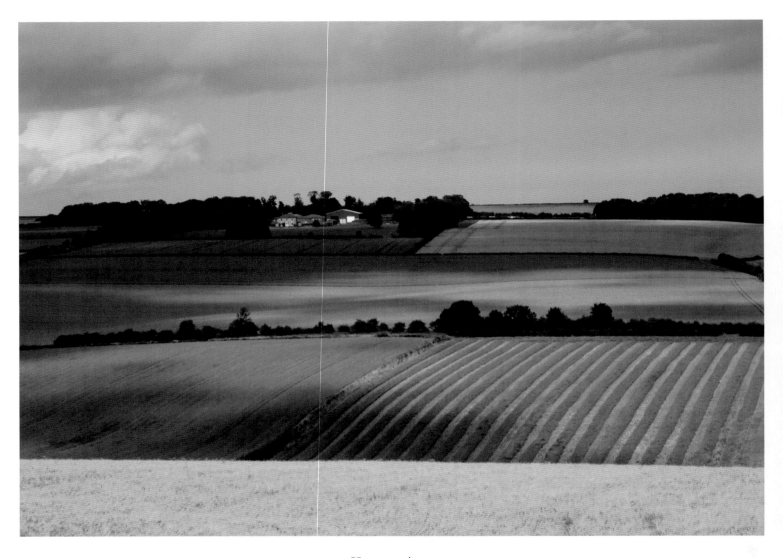

Harvest views
Here are two views over Wold landscapes between the villages of Kilham and
Thwing, showing the golden colours of ripening corn and oilseed rape.

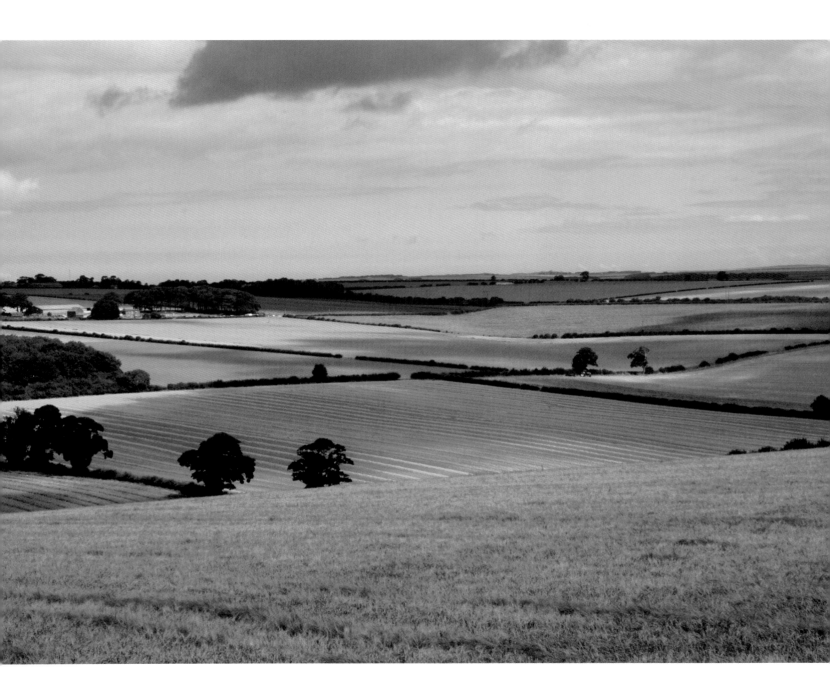

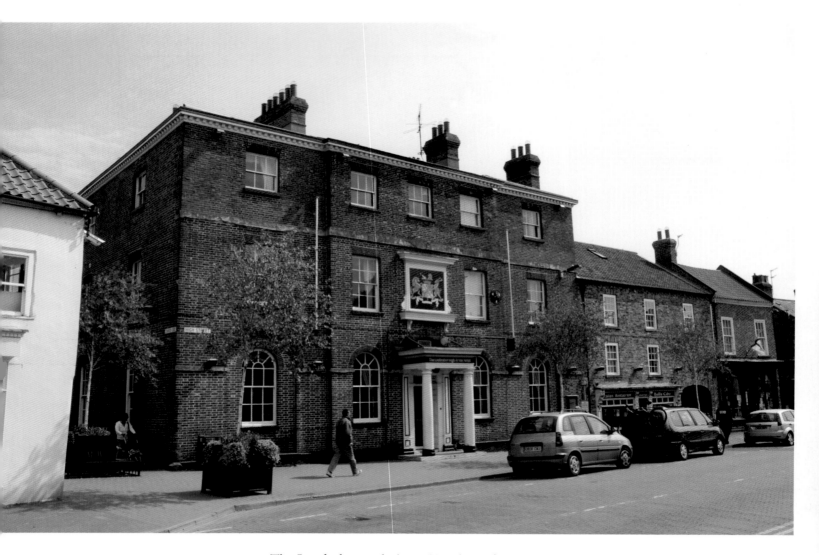

The Londesborough Arms Hotel, Market Weighton
This grand hotel in Market Weighton was designed by the renowned York architect
John Carr. It carries the arms of the Earl of Londesborough.

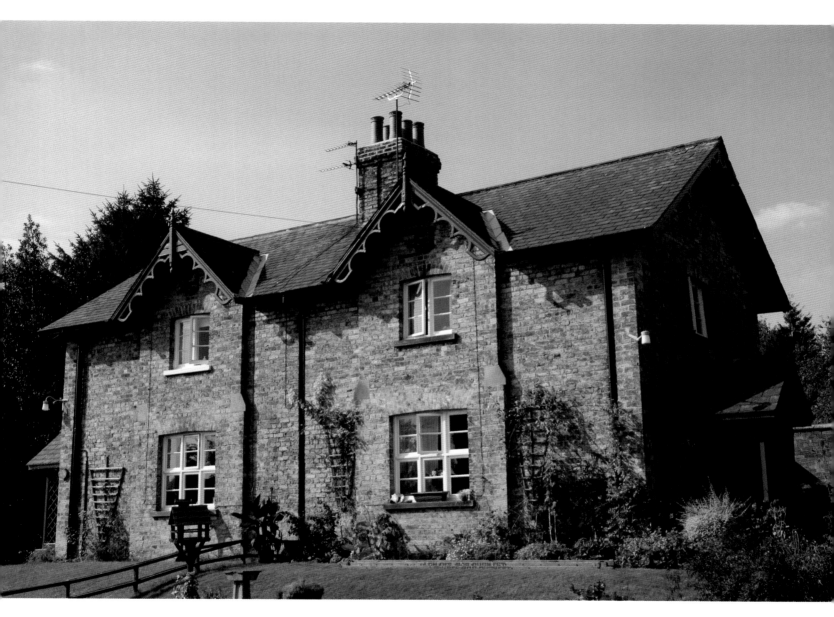

Estate cottages, Londesborough
Top Street in Londesborough has four pairs of estate cottages with decorative bargeboards and plaques with the family cipher.

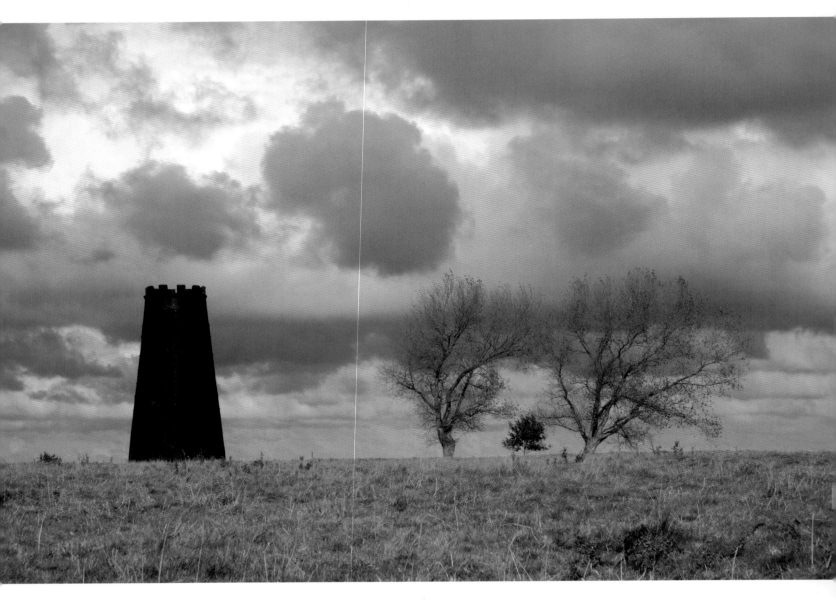

Black Mill, Beverley Westwood
The remains of a windmill stand on the high ground of Beverley Westwood. Windmill towers
were painted with bitumen to stop damp penetrating the brickwork and spoiling the grain and flour.

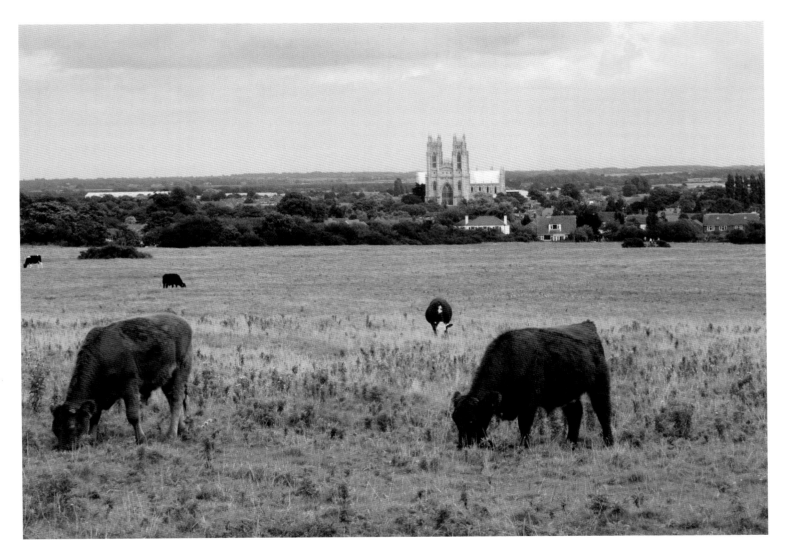

Cattle grazing on Beverley Westwood
Beverley and its Minster can be seen beyond the extensive area of common pasture known
as the Westwood. Each year Pasture Masters are elected to oversee the common.

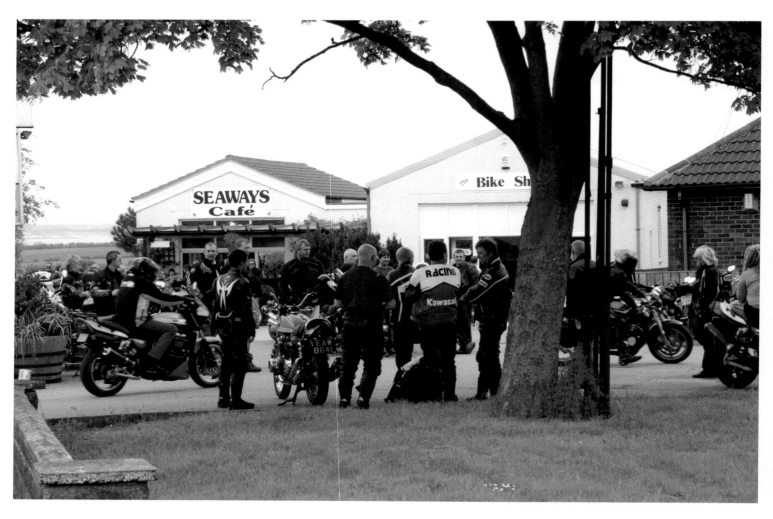

Seaways Café, Fridaythorpe
Bikers congregate outside the Seaways Café on the busy A166, the main coast road to Bridlington.

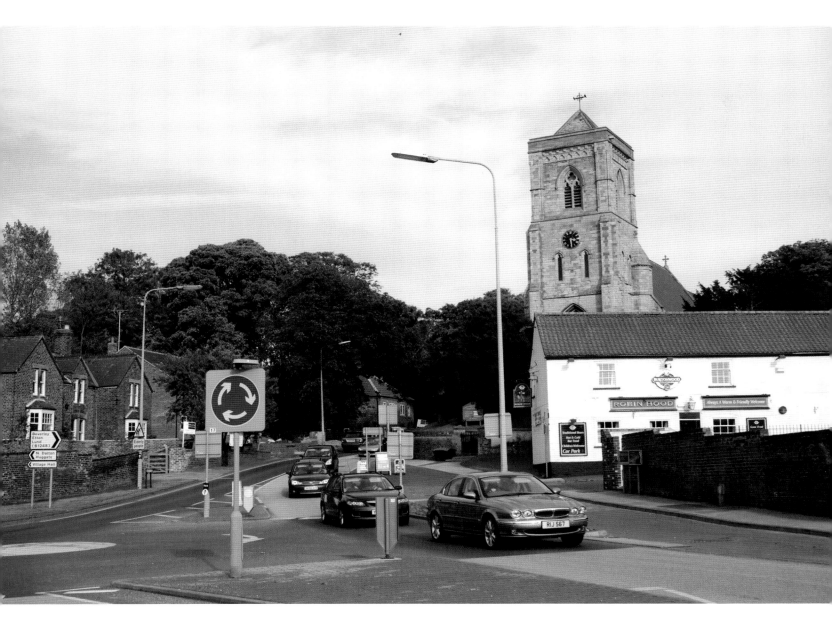

Middleton-on-the-Wolds
Cars pass through Middleton-on-the-Wolds on their way to and from the coast.

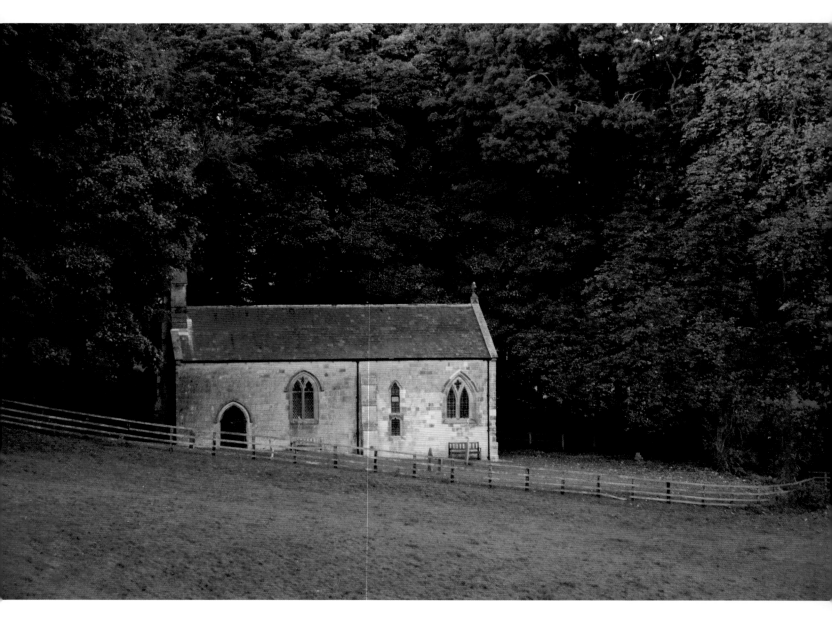

The church at Great Givendale
St Ethelburga's church serves the hamlet of Great Givendale and sits amongst trees at the head of the valley.

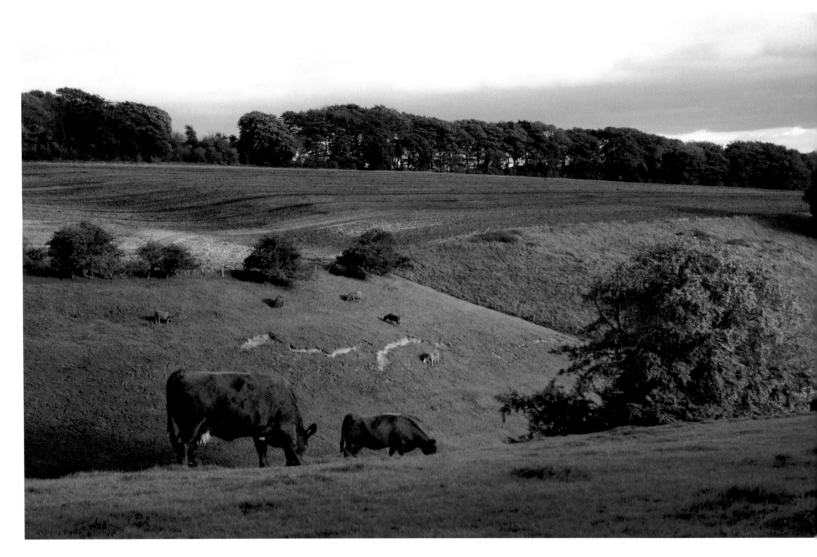

Cattle grazing
Cattle graze the steep slopes of Great Givendale.

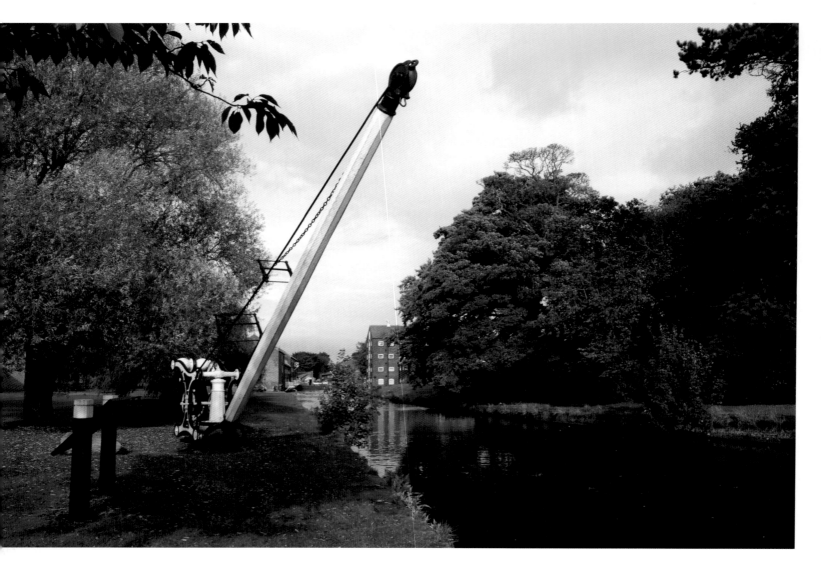

River Head, Driffield

This canal linked Driffield to the River Hull and it would once have been very busy with barges transporting agricultural produce from the Wolds. Now the cranes are disused, the warehouses have been converted into housing, and the towpath has become a pleasant walk.

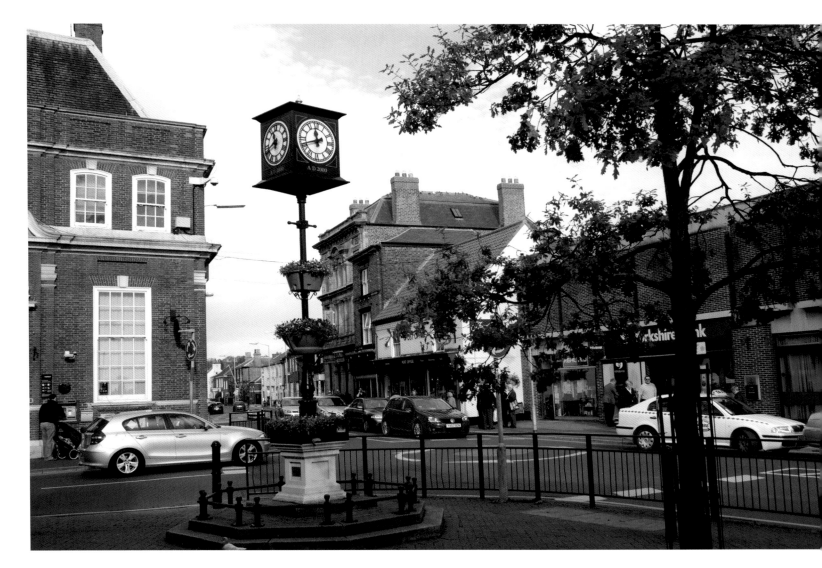

Market Place, Driffield
The millennium clock is a recent addition to the Market Place in the centre of Driffield,
a town that is known as the Capital of the Wolds.

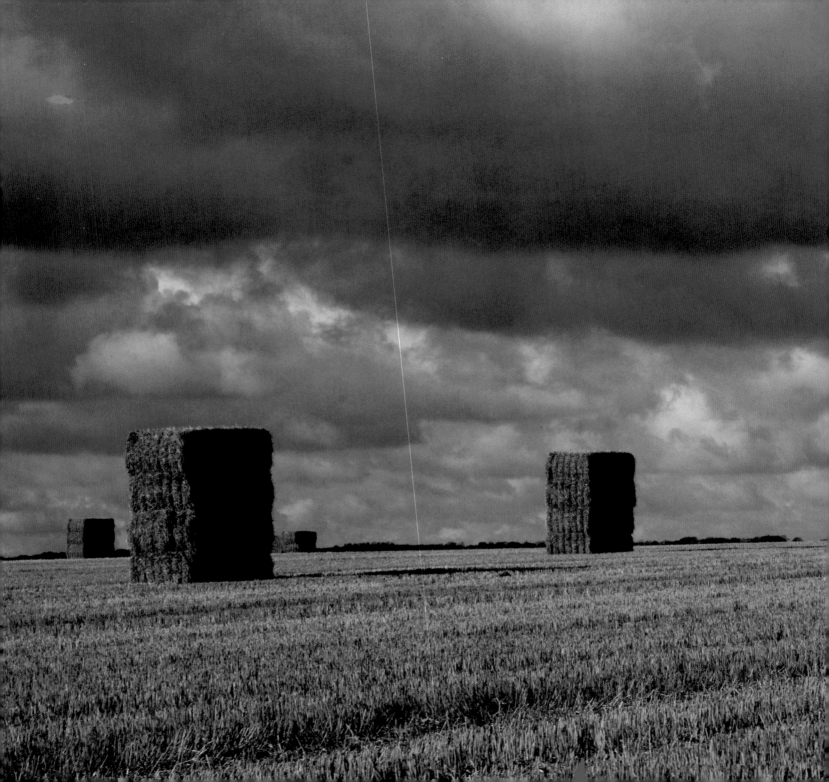

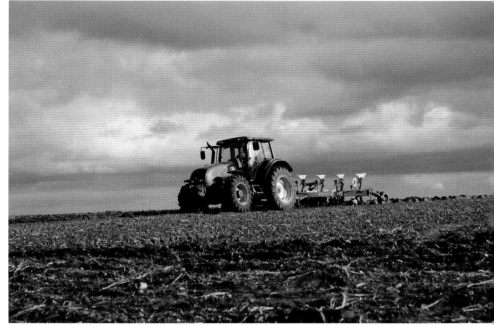

Above:
Ploughing near Cowlam
The harvest is over and ploughing is underway as the
farmer prepares the ground for next year's crop.

Left:
Threatening skies over Middleton Wold
Dark clouds gather but the bales of straw have been
stacked to protect them from the rain.

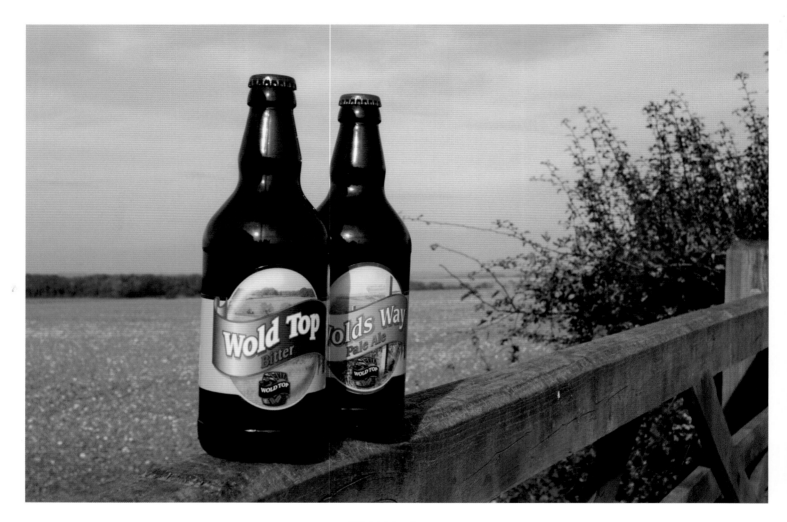

Wold Top beers
The Wold Top Brewery near Wold Newton is a farm microbrewery that uses
home-grown malting barley and chalk-filtered water to produce award-winning beer.

The Goodmanham Arms
The pub in Goodmanham also has its own microbrewery producing beers with
wonderful names such as 'Goodman Hammer' and 'Randy Monk'.

Cottage at South Dalton
This is one of the many attractive cottages that line the main street of South Dalton.

South Dalton
The very elegant tall spire of the parish church can be seen for miles around
and it is the most prominent landmark in the southern Wolds.

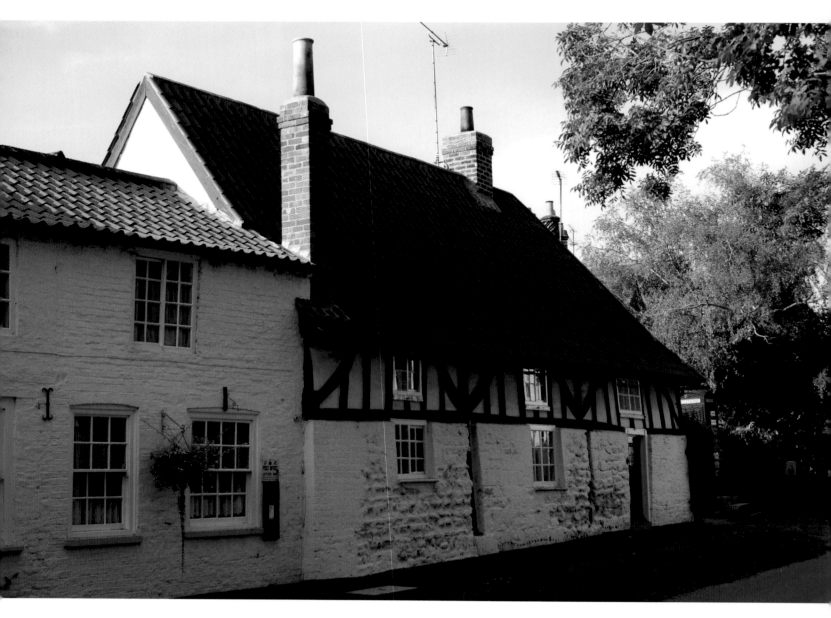

Oak Cottage, South Dalton
This seventeenth-century half-timbered cottage must be one of the oldest inhabited buildings on the Wolds.

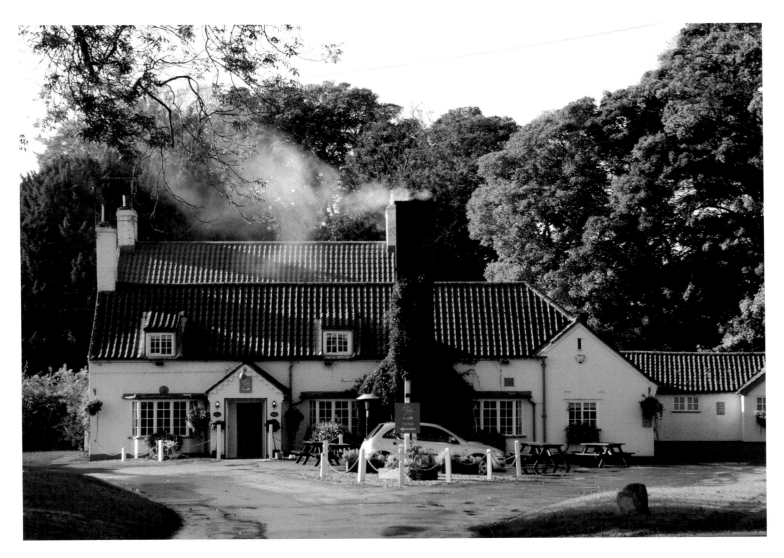

The Pipe and Glass Inn, South Dalton
The country pub and restaurant sits at the entrance to the parkland around Dalton Hall,
the home of the Hotham family for the past 200 years.

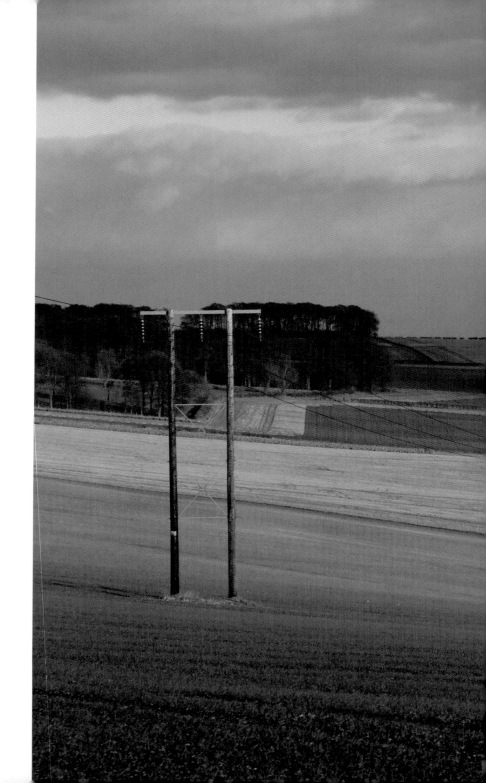

Telegraph posts cross Nunburnholme Wold

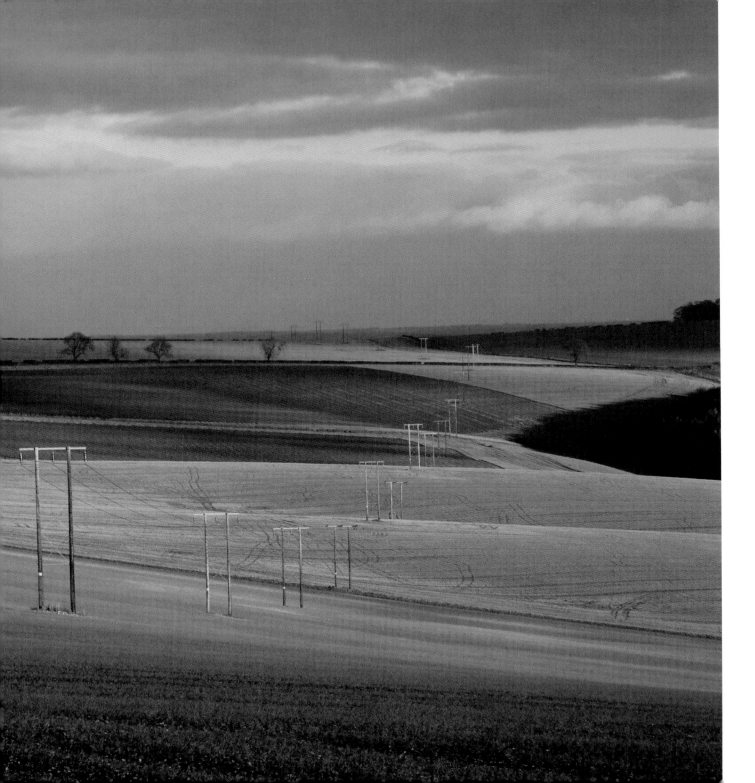

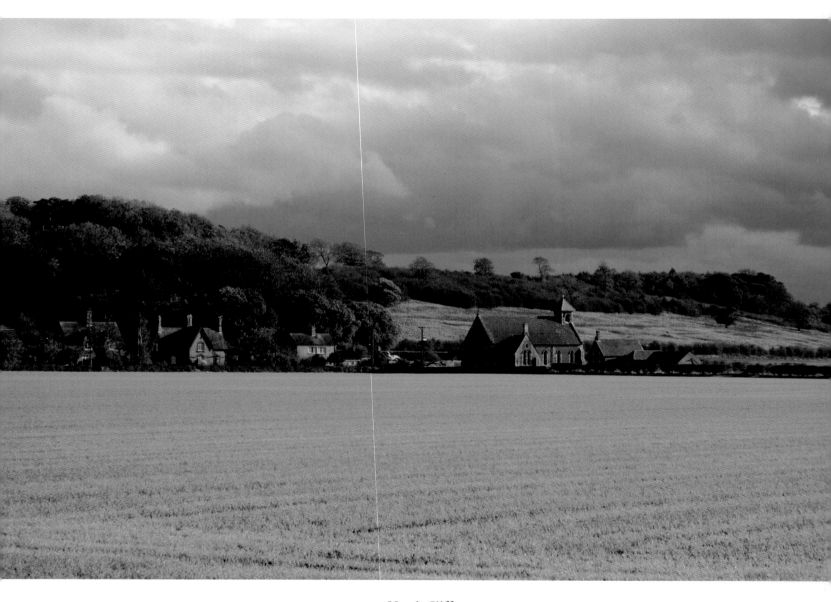

North Cliffe

The North Cliffe estate was purchased in 1861 by Samuel Fox who made his fortune through the invention of the modern umbrella frame. He was responsible for building the church and many of the houses in this little hamlet.

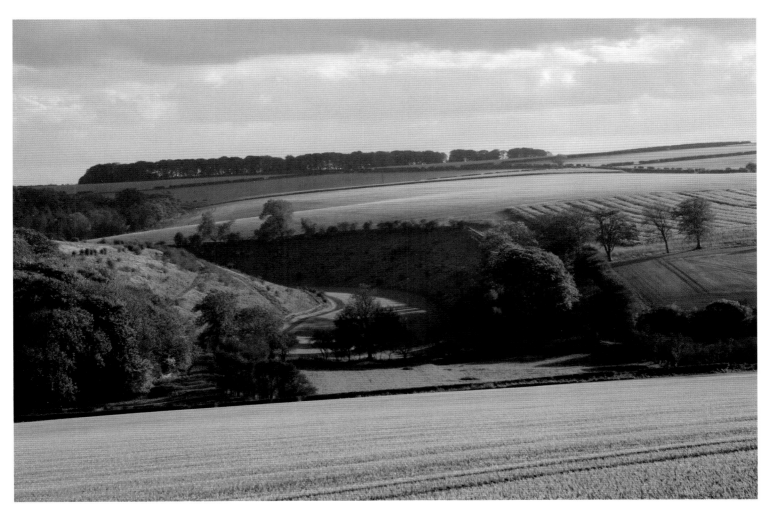

Great Dug Dale
A dry grassy dale cuts through the chalk wold near Warter.

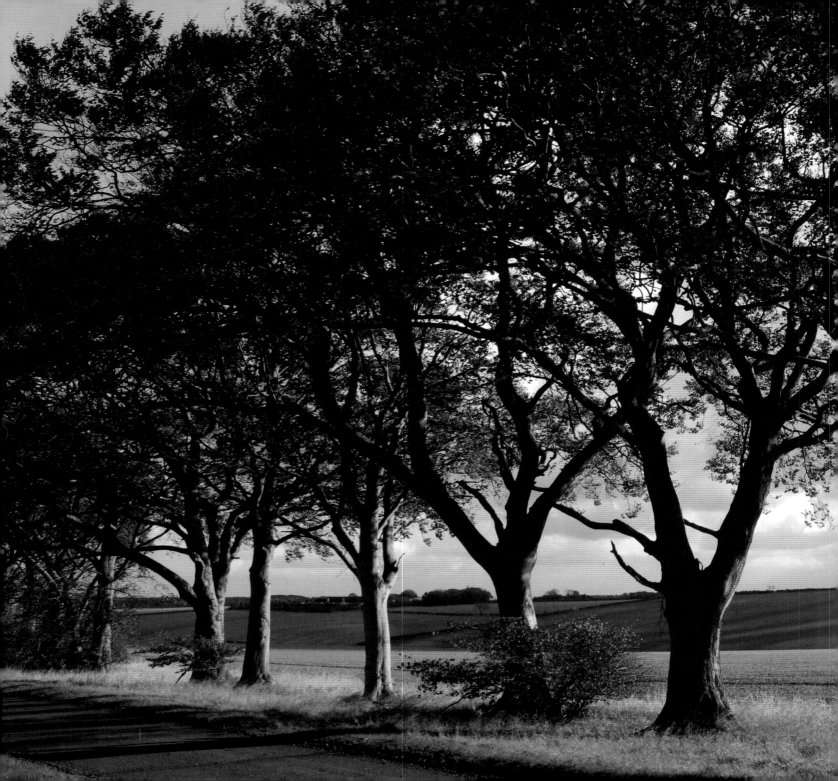

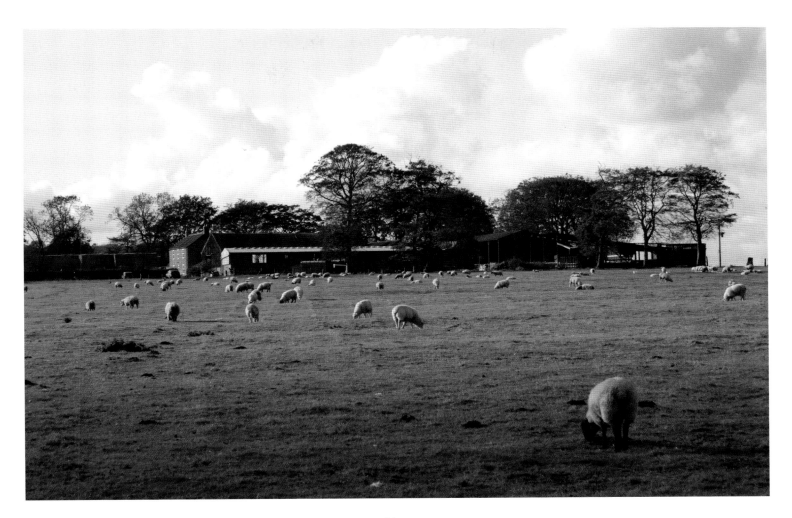

Above:
Grazing sheep on Middleton Wold
In the past a vast expanse of the Wolds was given over to unimproved pasture for sheep known as sheepwalks.
Now the Wolds are intensively farmed with a range of arable crops but sheep are still kept by some farmers.

Left:
Beech trees
Light catches the smooth grey trunks of a row of beech trees alongside the road over Middleton Wold.
Beech trees have been widely planted on the Wolds as they are tolerant of the chalky soil.

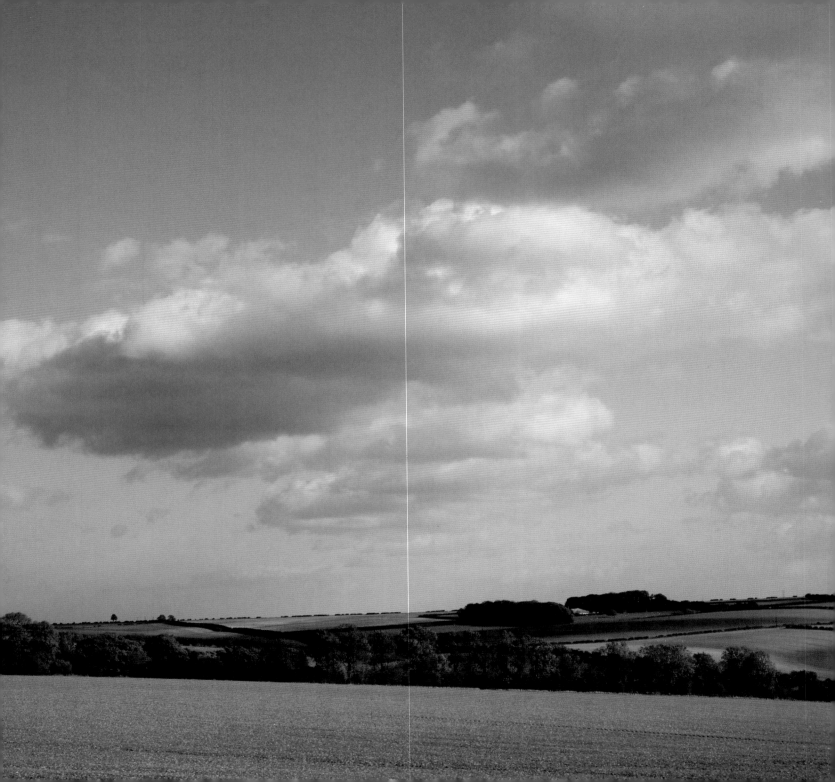

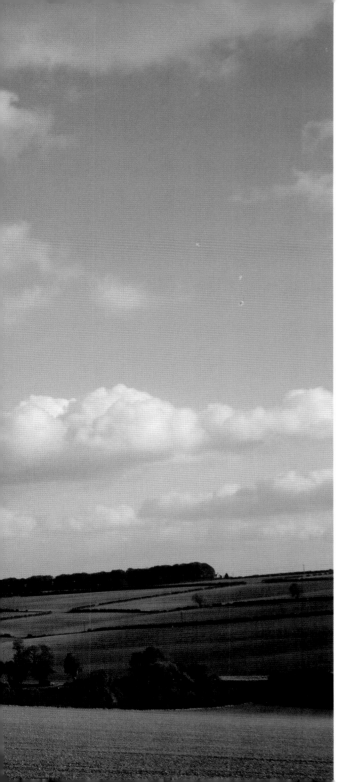

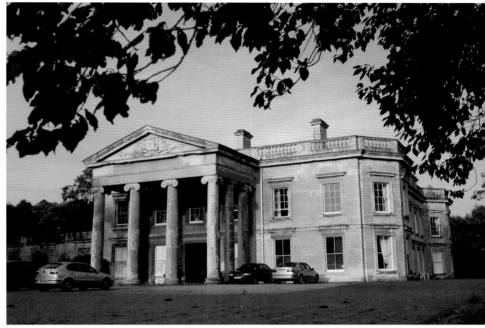

Above:
Kilnwick Percy Hall
The impressive building can be seen from the Pocklington road.
It was built in the eighteenth and nineteenth century but it now
has a new lease of life as the Madhyamaka Buddhist Centre.

Left:
Big skies over Warter Wold
Patterns of light and shade cross the Wold landscape.

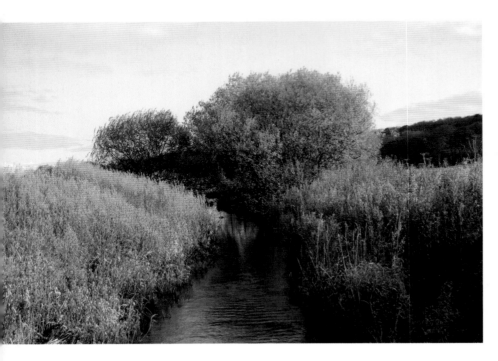

Above:

The Gypsey Race

This is the only stream that crosses the Wolds, flowing through
the Great Wold Valley and out to the sea at Bridlington.

Right:

Tunnel of trees, Woldgate

Woldgate follows the route of an old Roman road between
Kilham and Bridlington. For much of its length it runs along
the top of a ridge with superb views in all directions.

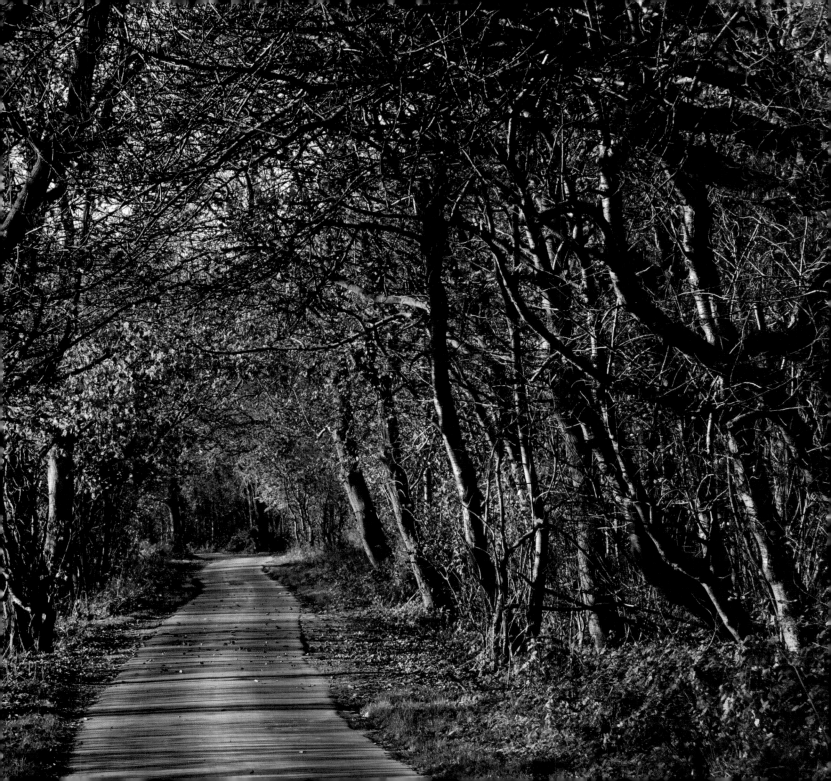

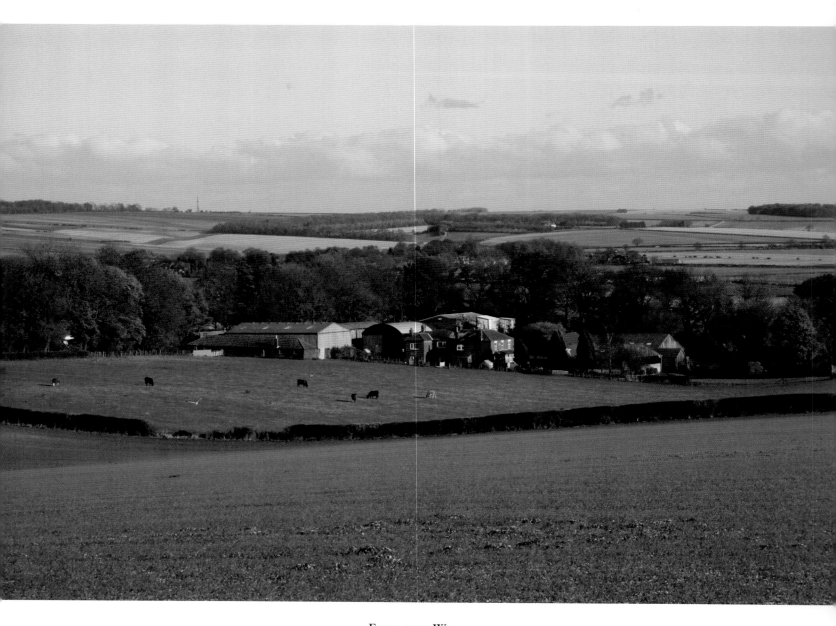

Farm near Wetwang
A typical Wolds farm is sheltered by its windbreak. The Sykes Monument on Garton Hill is visible on the skyline.

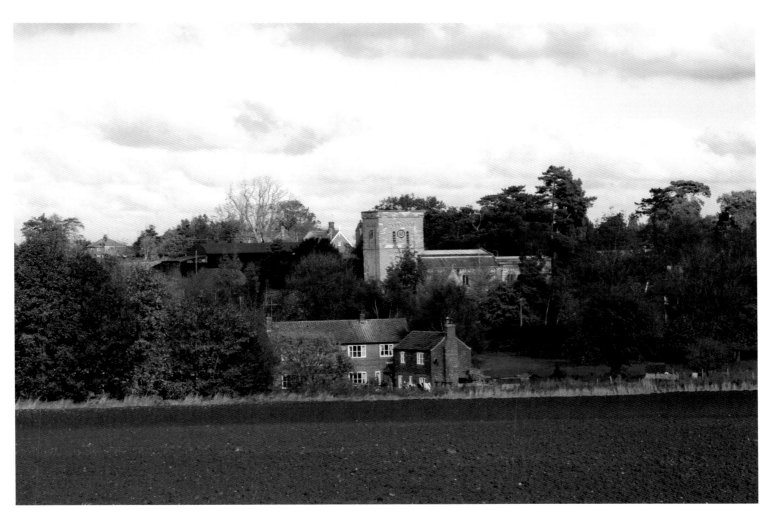

Etton
Red brick cottages and farmhouses cluster around the parish church in Etton.

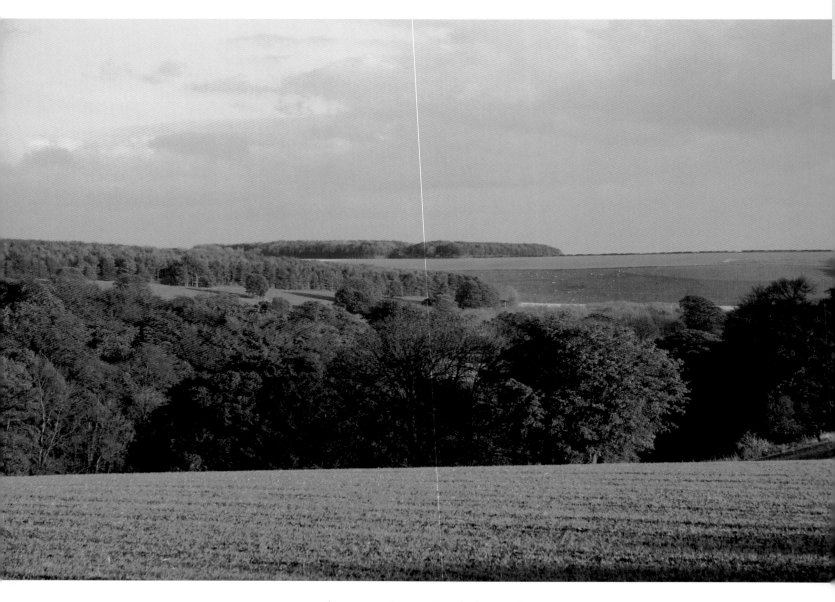

Autumn colour at Londesborough
Woodland plantations and shelterbelts are transformed in autumn when the
leaves of beech turn a beautiful coppery orange-brown colour.

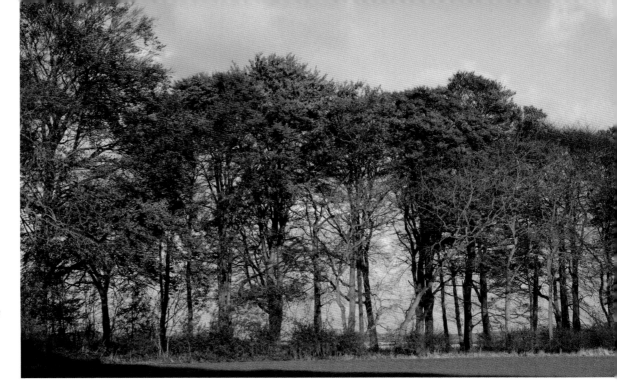

Autumn colour at Minningdale
Long plantations of beech trees are a feature of the open Wolds. Most were planted in the nineteenth century, either as aesthetic features of the landscape, or as windbreaks wrapped around the farms that were created when the open fields were enclosed.

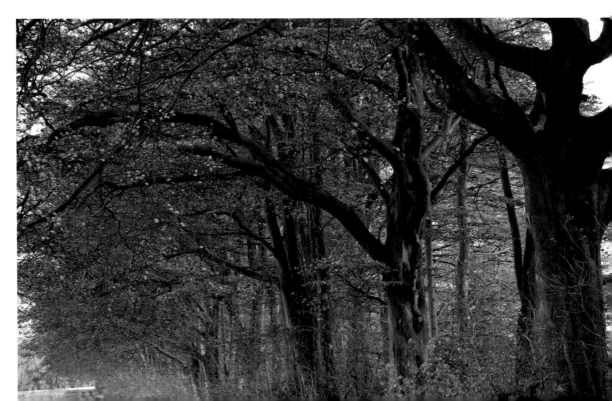

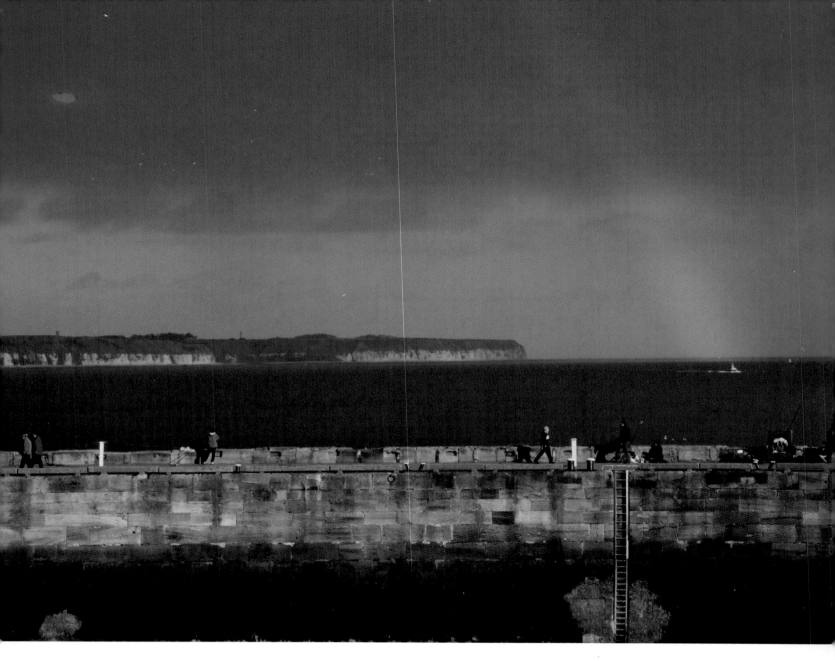

Rainbow
Strong light after the storm highlights the harbour wall at Bridlington and the distant chalk cliffs of Flamborough headland.